IMAGES
of America

GREATER HARRISBURG'S JEWISH COMMUNITY

ON THE COVER: Children of Harrisburg's Yeshiva Academy present a Hanukkah program on the stage of the Jewish Community Center's (JCC) auditorium in December 1964. Standing children hold placards representing the Hebrew letters on the four-sided Hanukkah dreidel (Yiddish for spinning top). The letters stand for the Hebrew phrase *Nes Gadol Haya Sham*, which means, "A great miracle happened there [Israel]." As a reminder of where the children are in America, pictures of George Washington and Abraham Lincoln provide the backdrop for Hanukkah themes of the struggle for liberation in the face of oppression. The message resounded for this audience, which traced its roots to immigrants escaping intolerance and poverty in Central and Eastern Europe for the promise of America. To the children's grandparents, who related stories of marginalization and arrival in Harrisburg, the rise of a prosperous Jewish community in the post–World War II era with a JCC, Jewish schools, numerous Jewish organizations, and vibrant synagogues must have seemed miraculous. (Courtesy Historical Society of Dauphin County.)

IMAGES
of America

GREATER HARRISBURG'S JEWISH COMMUNITY

Simon J. Bronner

ARCADIA
PUBLISHING

Published by Arcadia Publishing
Charleston SC, Chicago IL, Portsmouth NH, San Francisco CA

Printed in the United States of America

Library of Congress Control Number: 2009942545

For all general information contact Arcadia Publishing at:
Telephone 843-853-2070
Fax 843-853-0044
E-mail sales@arcadiapublishing.com
For customer service and orders:
Toll-Free 1-888-313-2665

Visit us on the Internet at www.arcadiapublishing.com

For Shulamit and Eitan, Harrisburg born and bred

CONTENTS

ACKNOWLEDGMENTS

This book relies on Arnold Zuckerman's exquisite photographs (1948–1974) in the collections of the Historical Society of Dauphin County (HSDC), where I benefited from the assistance of Kathryn McCorkle, Stephen Bachmann, and Ken Frew. Kudos go to my Penn State colleague, Michael Barton, for alerting me to Zuckerman's trove and much more. Another major source of material came from the Jewish Federation of Greater Harrisburg, for which I am grateful.

I appreciate the support of the Javitch Fund of the Jewish Community Foundation of Central Pennsylvania for this project. Foundation director Howard Ross and federation executive director Jay Steinberg provided crucial guidance. Sally Jo Bronner was terrific in her dual role as editor of the *Community Review* and understanding wife.

I owe thanks to community members who contributed photographs or information: Lois Lehrman Grass, Morton Spector, Herb Press, Sandy Silverstein, Andrea Lieber, Ted Merwin, Harvey Freedenberg, Davy Goldsmith, Richard Goldsmith, Susan Silver Cohen, Patti Bromley, DeDe Woolf, Steve Hevner, Sharon Siegfried, Gloria Grabenstein, Mark Eckman, Sue Dym, Gerry Morrison, Jay Krevsky, Richard Simons, Marilynn Kanenson, Ross Wiener, Adam Wiener, Lauren Castriota, Matthew Singer, Rabbi Akiva Males, Rabbi Carl Choper, and Rabbi Eric Cytrn.

As for published sources, I cite Michael Barton, *An Illustrated History of Greater Harrisburg* (2009); Michael Barton and Jessica Dorman, *Harrisburg's Old Eighth Ward* (2002); Michael Barton and Simon J. Bronner, *Steelton* (2008); Bruce Bazelon and George Friedman, *Chisuk Emuna: Strength of Faith* (1983); Arlene Benson, "The Jewish Residents of Harrisburg's Old Eighth Ward and Adjacent Neighborhoods, 1860–1924" (MA thesis, Penn State Harrisburg, 2008); Carol Levy Cohen, ed., *Community Review: Celebrating 75 Years* (2001); Michael B. Coleman, *The Jews of Harrisburg* (1978); Ken Frew, *Building Harrisburg: The Architects and Builders, 1719–1941* (2009); Stephanie Patterson Gilbert, ed., *Harrisburg's Old 8th Ward* Web site (www.old8thward.com, 2004–2005); *Historic B'nai Jacob Synagogue* (2004); Robert Allan Lehrman, ed., *Lehrmans in America, 1886–1986* (1986); *Temple Ohev Sholom, 1852–2002* (2002); Chaim E. Schertz, "Orthodoxy on the Periphery—Where It Counts," *Jewish Action* (Summer 2005); Bern Sharfman, *Their Gifts Keep Giving: The Saga of Mary Sachs and Her Two Co-worker Sisters* (2003); Ira Sheskin, *The United Jewish Community of Greater Harrisburg Community Study* (1994); Rabbi David L. Silver, *Silver Linings* (1997); *Temple Beth Shalom, 1971–1996* (1996); and *Yeshiva Academy of Harrisburg, 1944–1979* (1979).

All photographs are reproduced with the permission of the Historical Society of Dauphin County, unless otherwise indicated.

INTRODUCTION

The *Occident*, the first national Jewish periodical published in the United States, took notice of Harrisburg's Jewish community in 1858 because of the growth of the city's only synagogue, Temple Ohev Sholom, established six years earlier. Counting 20 members of the congregation, the paper commented that "the number of our people in the state capital must be quite considerable." Attracted by Harrisburg's rise as an upriver hub of trade and state capital, this handful of mostly German Jews—a small fraction of the city's population of 10,000—engaged primarily in clothing and other retail trades. During the 1860s, with the establishment of a school and cemetery and the hiring of a rabbi, the *Occident*'s editors hoped that Harrisburg's Jewish community could prosper and show a "progressive advance." Harrisburg emerged by the late 20th century as the major mid-state center for Jewish life and a fount for many national leaders in Jewish communal affairs. Time and again over its history, heads turned nationally in realization of Harrisburg's considerable commercial, social, and cultural accomplishment for a community its size.

Harrisburg's Jewish community numbered under 600 residents as late as 1905, but increased its size tenfold in the next decade when it received immigrants escaping pogroms, poverty, and oppression in Russia's restrictive Pale of Settlement. By the 1920s, Harrisburg's Jews attended a range of synagogues designated as reform, conservative, orthodox, and Hasidic and visited others in nearby Middletown and Steelton. Some religious and occupational differences could be discerned into the period, with the old German families identifying with the reform movement and the East European Jews affiliating with orthodoxy. In addition to the clothier and furniture stores set up by the German Jews, the Russian immigrants found opportunities in scrap metal, rag, and grocery lines of work.

In an effort to bridge ethnic divisions and live up to the "progressive advance" heralded by the *Occident*, Jewish civic leaders organized the United Jewish Community (UJC) in 1933 to bring together different social factions. An important component of community building was a Young Men's Hebrew Association (YMHA) formed in 1915 to provide Jews who had been concentrated in the Eighth Ward with cultural and recreational opportunities that synagogues did not provide. Another signal of social connection was the establishment the same year the UJC was formed of a community newspaper with local and international Jewish news called the *Community Review* to replace a limited Y newsletter issued since 1926. The Y changed its name to the Jewish Community Center (JCC) in 1941 and moved into a new expanded facility north by the city line in 1958 as Jews shifted their residences uptown because of the Capitol Park enlargement and upward mobility. Jews identified as Jews by joining a panoply of institutions, including the Harrisburg Hebrew School, Yeshiva, theater program, Hadassah, fraternities and sororities, youth and senior clubs, arts and cultural groups, and scout troops. The number was, again, amazingly high for a community the size of Harrisburg and featured an impressive array of organizations focused on Zionist, social welfare, women's, and youth activities.

The Great Depression and World War II took their toll on the population and spirit of Harrisburg. The city rebounded by the mid-20th century with a baby boom and economic growth, particularly in professions that augment the commercial base established by the previous generation. Harrisburg Jews were less involved in politics than one might expect from residents of the state capital, but in 1969, Miriam Menaker set a milestone by becoming the first Jew and woman to serve on the city council. Nationally known religious figures such as rabbis David Silver, Gerald Wolpe, and Philip David Bookstaber worked with dynamic community leaders to establish all the services and institutions offered in much larger communities, including a Jewish nursery school, Jewish kindergarten and day school (Yeshiva Academy), *mikveh*, *eruv*, kosher suppliers, Jewish day camp, and even a nonrestrictive Jewish country club. The community faced a number of serious challenges locally and internationally during the 1960s and 1970s, including combating anti-Semitism and advocating for civil rights and women's movements, providing aid after flooding caused by Hurricane Agnes, protesting treatment of Soviet Jewry, and extending support for Israel during wars in 1967 and 1973.

Toward the end of the 20th century, the community dispersed beyond its ethnic enclave between Division Street and Linglestown Road (colloquially called "Little Israel" by residents) in numerous directions—toward the West Shore of the Susquehanna River in Camp Hill, Mechanicsburg, and Carlisle; northeast into Susquehanna and Lower Paxton townships; and east to Hershey. Questions were raised about whether a sense of community could still hold without a traditional Jewish "neighborhood." The first synagogues to be established in the metropolitan area since the pre–World War II period sprouted in Mechanicsburg and Carlisle during the 1970s. Several factors contributed to the community's dispersal: increasing Jewish social mobility, getting away from the flood plain after Hurricane Agnes in 1972, and in that same year, the construction of Interstate 81. By 1990, the population reached an all-time high, exceeding the 10,000 mark in more municipalities than in the past, before dropping in the 21st century.

If no longer situated in a core neighborhood or as organizationally active, the diverse Jewish community is still engaged socially in a number of common causes such as advancing Jewish education and social justice, absorption of new immigrants from the former Soviet Union and Islamic countries, commemoration of the Holocaust, advocacy for social tolerance, and appreciation for Jewish heritage and culture. Seeking to engage the diffusing population, synagogues and the JCC faced similar decisions during the 1990s about whether to follow the path of their flock or stay put to create Jewish destinations rather than homes in the city. Additionally, the digital age had changed notions of communal connection with Jewish Harrisburg Web sites, Listservs, and blogs. In the 21st century, the Jewish Federation of Greater Harrisburg, replacing the UJC, reaches out more than ever to the broader society with events such as the annual Jewish Film Festival, Holocaust Memorial in Riverside Park, and cultural concert series.

Despite significant social change over time, a connecting theme, or distinction, for the Harrisburg Jewish experience is the formidable effort of creating a community presence. Descendants of immigrants from Central and Eastern Europe tell a story of a rise from society's margins to arrival. Harrisburg's Jews have acquired, on average, more affluence than those in comparable cities and used it to support external Jewish causes and construct a local institutional infrastructure that appears created for a larger community. As far as the communal definition of Jewishness as religious or cultural, surveys show that Harrisburg's Jews have steadily secularized over time more than other comparable cities, and yet a portion has remained steadfast in its orthodoxy. Another paradox is the community's combination of rooted families with a constant influx and departure of new blood. If a number of narratives are contained within the Harrisburg Jewish experience, one strong theme in this book is the way the JCC took on a special role in this capital river city as a unifying, energizing force for building community and social tolerance. Again and again, Harrisburg was known for doing more than its share.

One

BEGINNINGS

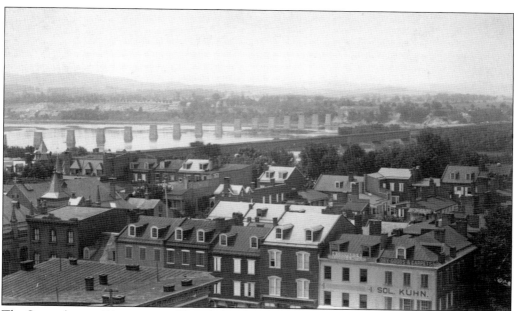

The Susquehanna River, pictured here behind the section of Harrisburg called the Eighth Ward, was a commercial thoroughfare in the 19th century that attracted intrepid Jewish merchants to come inland and set up shop. At the lower right on Market Street, near Market Square, is Solomon Kuhn's store for dry goods and carpets.

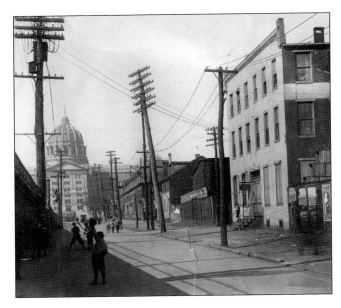

The Pennsylvania State Capitol is prominent on Harrisburg's cityscape in this view of the Eighth Ward. Many Jews resided there in the late 19th century before multiple houses were razed to make way for the Capitol Park expansion in 1912. This photograph is of the north side of State Street, looking from the Pennsylvania Railroad. State Street was home to Jewish establishments including Kesher Israel synagogue (400), Machisky Hadas Hasidic Congregation (services were held in basement of the Kesher Israel building), Joseph O. Nathanson's dry goods store (441), and Joseph and Henry Claster's clothing store (600).

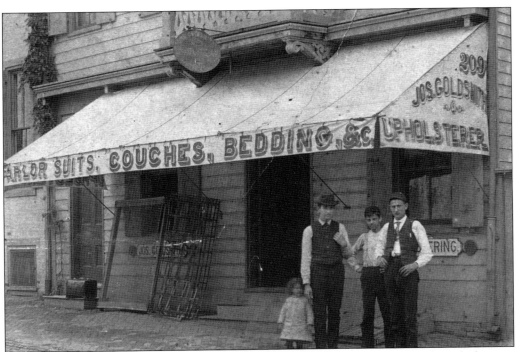

A 19th-century arrival in Harrisburg from Germany, Joseph Goldsmith set up the upholstering and furniture store pictured here at 207–209 Locust Street. He resided at the address as well. Born in 1854, he came to Harrisburg at the age of 16 and married Frieda Kuhn, who was from a Harrisburg Jewish family. The business, which later became M. Lee Goldsmith and Son, stayed in the family for another century. (Courtesy Richard Goldsmith.)

Pictured here is the printing plant of the Lowengard brothers, Leon (1886–1951) and Harry (1885–1926). Their Bohemian-born father, Joseph, was an early Jewish arrival in Harrisburg in 1852 who established a clothing business. Leon was active in Jewish civic affairs; he became the first president of Harrisburg's YMHA in 1916. Upon his death in 1951, the *Community Review* called him "the father of our Jewish Community Center."

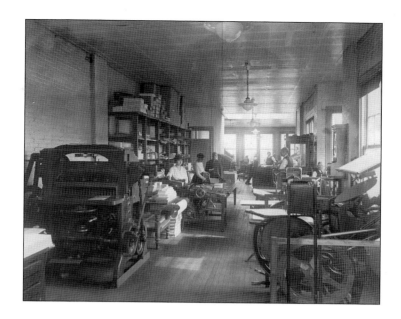

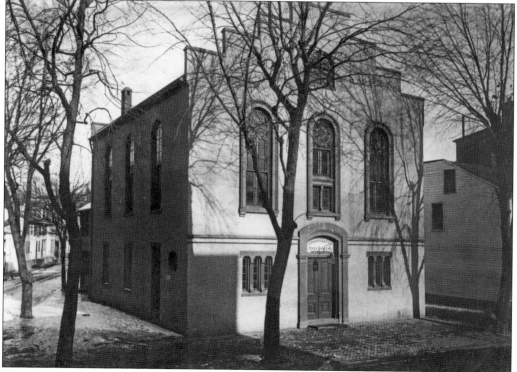

The first Jewish congregation in Harrisburg, originally an orthodox group calling itself "Ohef Sholem" (later to become Ohev Sholom), was established in 1852 by 24 families residing in the city. In 1865, the congregation purchased the building pictured here for use as its first temple at Second and South Streets. Two years later, members changed the temple's affiliation to Reform, growing in popularity among German American Jews.

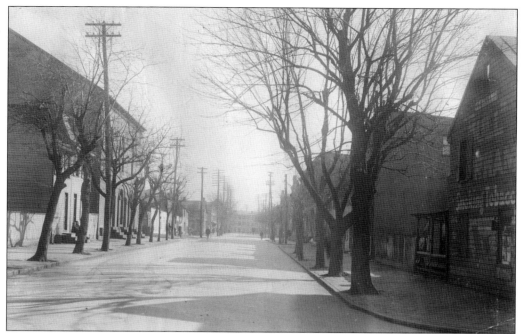

The brick building for the Chisuk Emuna Congregation is visible in this early photograph of Filbert Street, looking from North Street in Harrisburg. It replaced a wooden structure on the site that had been gutted by fire in 1905. Lithuanian Jews, newly arrived in Harrisburg, formed the Yiddish-speaking orthodox congregation on December 5, 1883. The Filbert Street synagogue was dedicated on September 22, 1894, in the Eighth Ward. The congregation remained on Filbert Street until 1917, when it moved north to a larger structure on Sixth and Forster Streets.

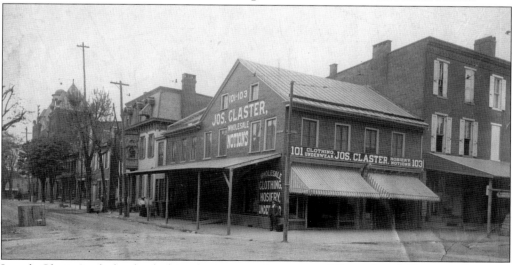

Joseph Claster's wholesale clothing business at the corner of Second and Chestnut Streets is pictured here in the 1890s. An early Russian immigrant, Joseph's father, Hyman, had arrived in Harrisburg around 1854. Hyman opened a peddler's supply house at Cowden and State Streets, and Joseph, who arrived in America at the age of eight with his mother, expanded his father's wholesale trade.

Pictured here around 1900 is Aaron Baskind's grocery on Tanners Alley, one of several run by recent Russian Jewish immigrants, which served as their residences. The alley was a small side street running between Walnut and South Streets in Harrisburg's old Eighth Ward. In 1902, Baskind was able to move his grocery into larger quarters at 410 Cranberry Avenue.

To the left of this photograph taken between 1901 and 1903 is the pawnbroker's symbol at Jacob Tausig's Market Street jewelry store and loan office, established, the sign announces, in 1867. Born in Bohemia in 1825, Tausig followed the path of peddling common among Jewish immigrants before creating a loan office. With the help of his sons, Herman and Edward, he expanded his business into jewelry, notions, and pawnbroking.

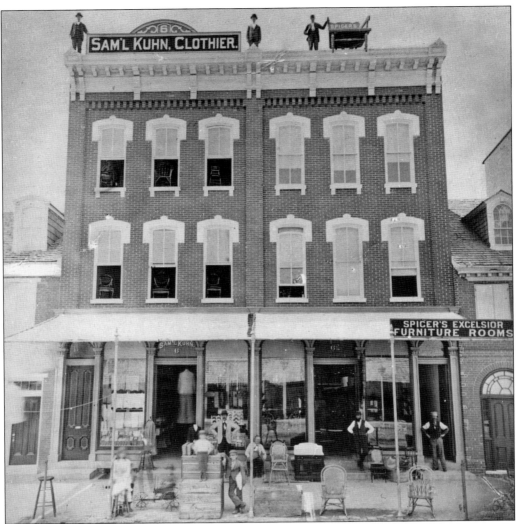

Samuel Kuhn's clothing store was located at 6 North Second Street in Harrisburg. After coming as a teenager to Harrisburg before the Civil War, the German-born Kuhn landed a job in the clothing store of fellow German Jew Joseph Strouse on Market Street. By age 20, he started his own business featuring ready-to-wear clothing appealing to the working class. The Kuhn Clothing Company he established became successful, and according to local historian Michael Coleman, it had the distinction of being "the oldest continuous Jewish retail business in Harrisburg before it was closed in 1967." Two of his nephews continued the business along with Morris Jacobson, who had worked in his store. Kuhn was active in Jewish civic organizations such as the Hebrew Charity Association (a forerunner of Jewish Family Service), which sponsored an annual fund-raising ball addressing children's welfare and health issues among the Jewish poor.

On the left side of this photograph of Cowden and South Streets is Abraham Cohen's poster-covered shoe repair business at 123 Cowden Street. Across the street is Lewis Silbert's confectionery and ice cream parlor. Silbert, a Russian Jew, had mounted a large poster in his store window advertising a Yiddish play at the Majestic Theatre at 323 Walnut Street, run by fellow Jews Nathan Appell and Moses Reis.

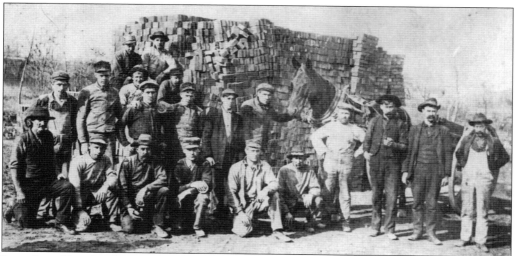

Less than 10 miles downriver from Harrisburg in Middletown, about 20 mostly Lithuanian Jewish families settled in as merchants and laborers amid the town's growing number of mills and factories. Lithuanian-born Philip Singer (1861–1950) stands fourth from the left in the second row at a local brickyard supplying bricks for B'nai Jacob synagogue in 1905. (Courtesy B'nai Jacob synagogue.)

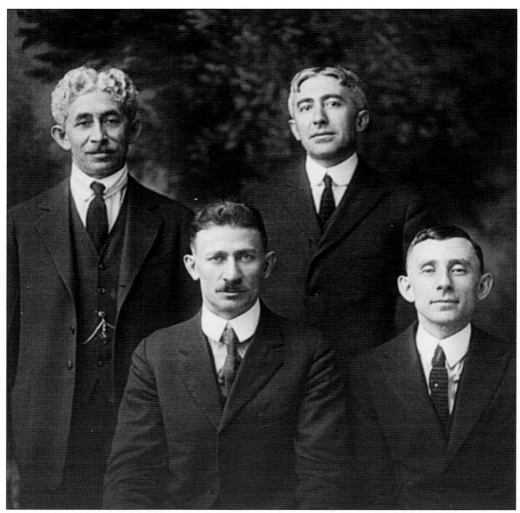

This 1922 studio photograph brought Steelton merchants Louis (top right), Samuel (bottom left), and Abe "A. J." (bottom right) Lehrman together with their older brother Nathan (top left, b. 1874), who had ventured west to Colorado. They were all born in Kublitz in the Russian Empire and ventured by steamship at different times to America. Samuel (1877–1948) landed in New York in 1898 and took a job as a Hebrew teacher in Middletown. He moved to Steelton to help with Jewish education at the Tiphereth Israel Congregation, which had been established in 1904 (a building was erected at 9 South Second Street). He opened a grocery store near the Bethlehem Steel Works and was joined shortly in town first by Louis (1881–1959), who also went into the grocery business, and then by A. J. (1883–1961), who opened a clothing business after clerking in a Steelton men's clothing store. (Courtesy Lois Lehrman Grass.)

Two

SYNAGOGUES, SCHOOLS, AND SIMCHAS

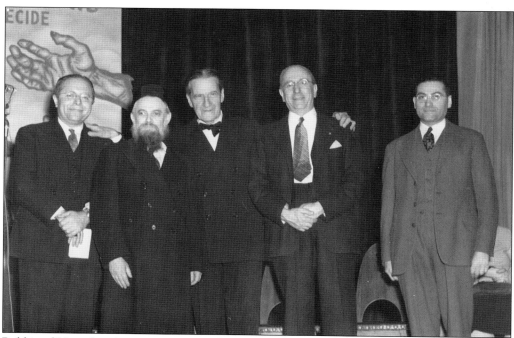

Rabbis of Harrisburg's congregations rallied together in a sign of unity with renowned Jewish leader Rabbi Stephen Samuel Wise (1874–1949), third from left, to raise funds for Holocaust survivors. Surrounding him are, from left to right, Reuben Magill of conservative Beth El Temple, Rabbi Moses Etter of the orthodox (later conservative) Chisuk Emuna Congregation, Rabbi Philip David Bookstaber of reform Temple Ohev Sholom, and Rabbi David L. Silver of orthodox Kesher Israel.

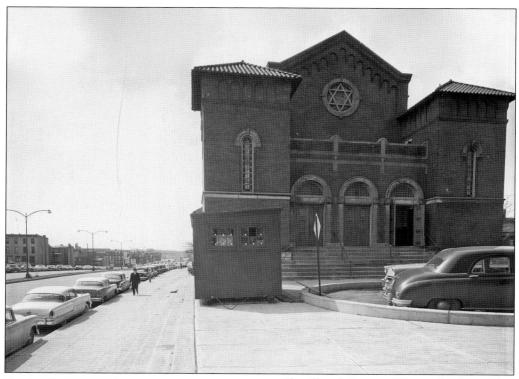

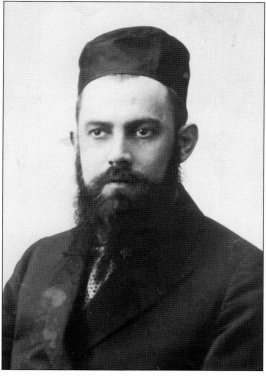

The Chisuk Emuna ("Strength of Faith") Congregation, founded in 1883 as a Yiddish-speaking orthodox group, moved from its Filbert Street location in the old Eighth Ward in 1917 to a new and larger building on Sixth and Forster Streets, pictured above in 1956. In that same year the congregation voted to affiliate formally with the United Synagogue of America, the organization of conservative Judaism. The orthodox rabbi Moses Etter was born in 1883 in Kupischek, Lithuania, and had been the rabbi of Cherchesk, in what is now Belarus, before leaving for Harrisburg in 1923 to join his sister and brother in the area. Etter was rabbi of Chisuk Emuna in 1925 until 1946, when he left under pressure to serve the Hasidic congregation of Machsikey Hadas until 1954.

Pictured here is the second home of the orthodox Kesher Israel (KI) Synagogue, built in 1918, at Capital and Briggs Streets. The congregation used this building until a new uptown site on North Third Street was developed in 1949. The exterior shows signs of Moorish Revival architecture; its design is reminiscent of the celebrated Great Synagogue of Pilsen, built in 1893 in what is now the Czech Republic.

Lithuanian-born Rabbi Eliezer Silver (1882–1968) speaks at the cornerstone ceremony for KI's third home at North Third and Schuylkill Streets in 1948. He served as KI's rabbi from 1909 to 1925. Called one of "American Jewry's foremost religious leaders," Eliezer became president of the Union of Orthodox Rabbis of the United States and Canada, organized the Hebrew Free Loan Society, and was a founder of Agudath Israel of America.

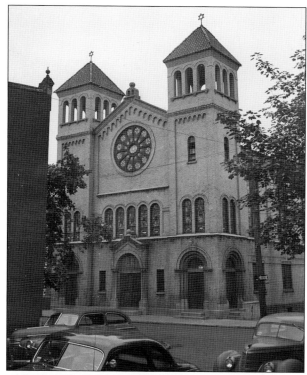

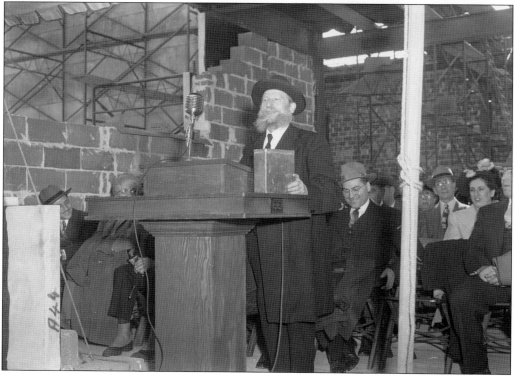

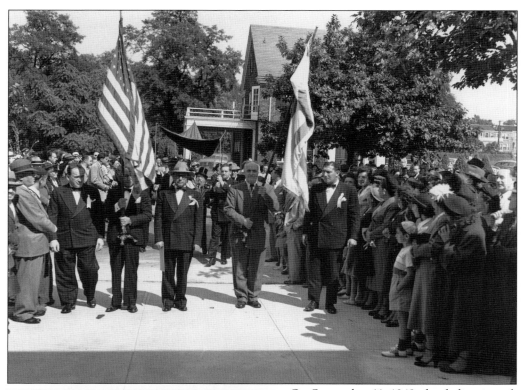

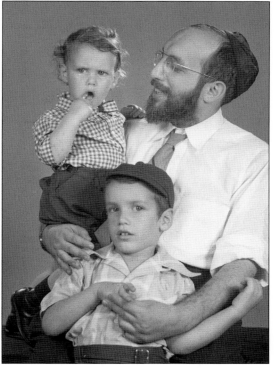

On September 11, 1949, the dedication of Kesher Israel's new synagogue on North Third Street began with a procession from the congregation's old synagogue at Capital and Briggs Streets to the new site. Flanked by flag bearers for the American and Israeli flags is Harry Hartman, chairman of the dedication events. Behind him, Rabbi Eliezer Silver holds a Torah, metaphorically a bride, under a ceremonial *hupah*. In a ritual of transference from the old to the new, the congregation's oldest member, Hyman Cohen, handed the Torah at the old site to Rabbi Silver for the procession, and both men kissed it. Hungarian-born Holocaust survivor David Baum, pictured at left with his children in 1953, served as cantor at the dedication for Kesher Israel. In addition to chanting at services, Harrisburg's cantors frequently showcased their talents in public concerts sponsored by the JCC. Harrisburg's cantorate was exclusively male until the 1990s, when women were hired as cantors for Beth El and Ohev Sholom.

Rabbi David L. Silver (1907–2001) served Kesher Israel for over 50 years. A sign of his modernity is breaking from orthodox tradition and his father's example of being clean-shaven. Yet he also admitted in his memoir, "I am not a liberal interpreter of halacha."

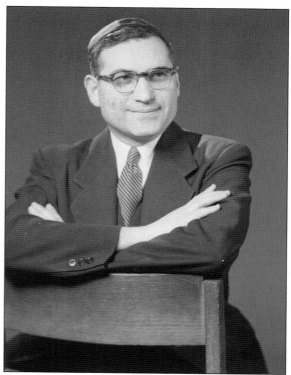

Dr. Chaim E. Schertz succeeded David Silver as rabbi of Kesher Israel in 1984, and he served until his retirement in 2008. He worked to maintain a "geographically recognizable Jewish neighborhood" around the synagogue, as he wrote in the national orthodox magazine *Jewish Action* in 2005. He also received press attention for his public stands against homosexuality and the "intelligent design" educational movement. (Courtesy Jewish Federation of Greater Harrisburg.)

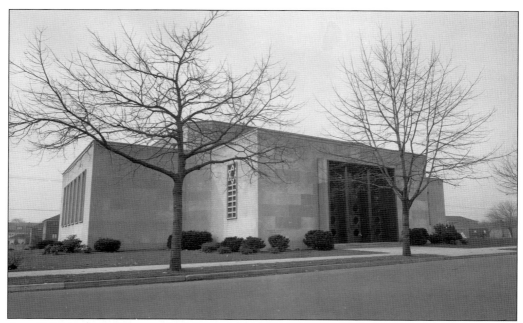

Arnold Zuckerman photographed these views of Kesher Israel synagogue on North Third Street four years after the building's dedication on September 11, 1949. The modernist appearance, in keeping with the congregation's self-image as "modern orthodox," was designed by local architect James William Minick (1898–1949), who also developed the look of the Zembo Shrine near the synagogue. In 1963, a matching linear-edge architectural style addition was built containing a social hall, daily chapel, kosher kitchens, offices, and meeting rooms. Notable changes to the interior from the previous site built in 1918 were the movement of the *bimah* from the center to the front and the replacement of a loft for women by a single open-view level.

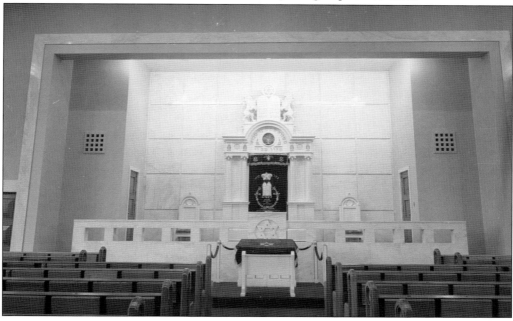

A glimpse of orthodox Jewish worship in the early years of the Greater Harrisburg community is provided by the restoration of B'nai Jacob in Middletown. Completed in 1906, the building was designed and constructed by charter members of the congregation who mostly hailed from Lithuania and apparently styled their house of worship on memories of the old country. The largely unaltered interior featured a central *bimah*, loft for women, and large windows to let in extra light. The ark is supported by neoclassical columns, topped with a handcrafted Decalogue flanked by lions of Judah. Threatened with neglect and shopping center developers' bulldozers during the 1980s, descendants of the charter members placed the structure on the National Register of Historic Places in 1985. Although most congregants no longer reside in Middletown, the synagogue has continued with High Holiday services and semi-regular Shabbat services. (Right, photograph by Simon Bronner; below, courtesy B'nai Jacob synagogue.)

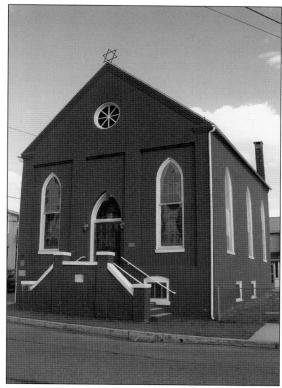

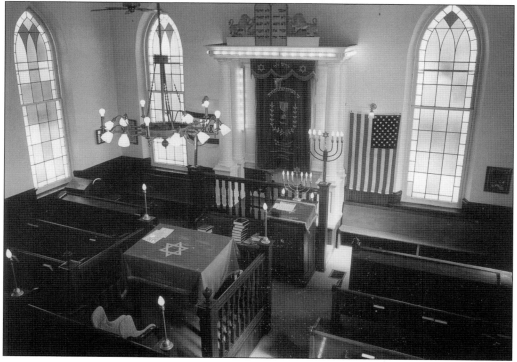

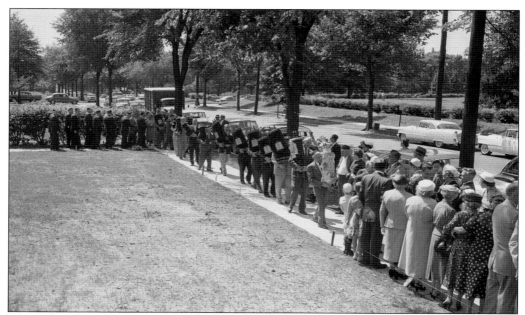

The dedication ceremonies for Chisuk Emuna Congregation's new uptown home on Division and Fifth Streets (shown here) occurred on June 9, 1957, with a Torah procession and ribbon cutting at the synagogue entrance. The congregation had changed its liturgy a year earlier from orthodox to conservative with formal affiliation with the United Synagogue of America. The loss of the generation of Old World members was made up with additions from a congregation from the Allison Hill section of Harrisburg that called themselves the Hill Temple Association. According to synagogue historian Bruce Bazelon, membership dramatically increased from about 80 in 1957 to about 250 members in 1960. A few months after the dedication, the synagogue welcomed its first conservative rabbi, Abraham Eckstein, who stayed until 1960. An addition was constructed to expand the sanctuary in 1983. On April 3, 2009, a two-alarm fire severely damaged the synagogue, and the congregation relocated farther uptown to Vaughn and Green Streets.

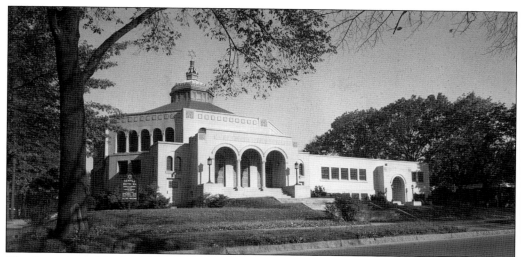

The formation of Beth El Temple resulted from younger, English-speaking members of Chisuk Emuna splitting off to form a more liberal institution in 1925. Ground was broken on April 1, 1928, at Front and Wiconisco Streets for a new uptown building. The building's architect was Clayton Lappley (1892–1964). Associated with English manor or Gothic Revival styles in his other buildings, Lappley applied a Moorish theme inside and out that is plainly visible in this photograph from 1950. The key feature is a minaret, a cupola surmounted by a lantern; it also appears at the top of Lappley's later design of the Payne-Shoemaker building downtown. In 1952, an additional wing was added to house Sisterhood Hall, classrooms, and offices. Other major renovation projects occurred in 1981 and 2009.

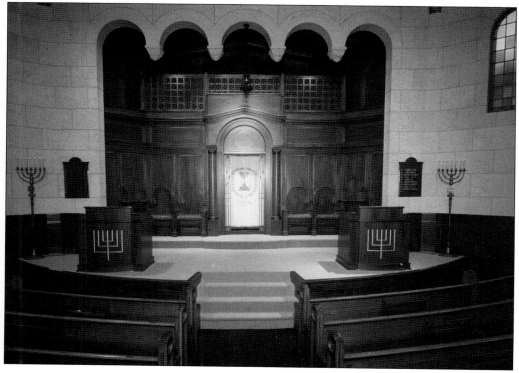

Rabbi Gerald Wolpe (1927–2009) came to Beth El Temple in 1958 and served for 11 years. He went on to national renown as an expert in bioethics, caregiving, and medical education. After his stint in Harrisburg, he moved to Philadelphia, where he served as rabbi for Temple Har Zion and returned often to Harrisburg to speak at special events. (Courtesy Jewish Federation of Greater Harrisburg.)

Reform rabbi Philip David Bookstaber (1892–1964) became the rabbi of Ohev Sholom in 1924 and served until his retirement in 1962. He wrote widely known books on Judaism, championed the scouting experience, and led campaigns for the UJC. He was awarded the Commonwealth Medal, the highest commendation given by the state for community service. (Courtesy Jewish Federation of Greater Harrisburg.)

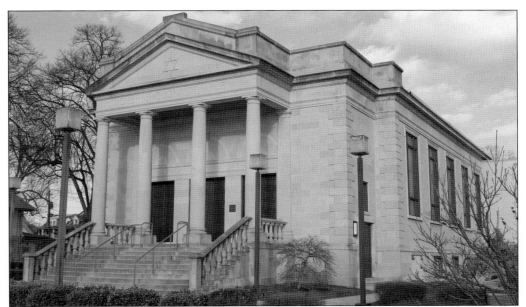

Ohev Sholom, Harrisburg's oldest Jewish congregation, moved uptown in 1920 to a classical edifice facing the Susquehanna River at Front and Seneca Streets. Designed by Harrisburg architect Frank Gordon Fahnestock Jr., the synagogue building, made out of Indiana limestone, is distinguished as a religious structure by its Roman temple style with large columns holding up a classical pediment. The sanctuary is therefore long and narrow compared to those of other synagogues in the city. According to architectural historian Ken Frew, "Ohev Sholom's building committee chairman was Henry C. Claster, a noted architectural buff who liked to make a statement with his buildings." (The remodeled Claster Building at 112 Market Street, completed the same year as the synagogue, featured an art moderne look with geometric decorations and chevrons in relief). Above the doors are inscribed the biblical motto of religious tolerance, "My House Shall Be Called A House of Prayer for All Peoples" (Isaiah 56:7). (Above, photograph by Simon Bronner.)

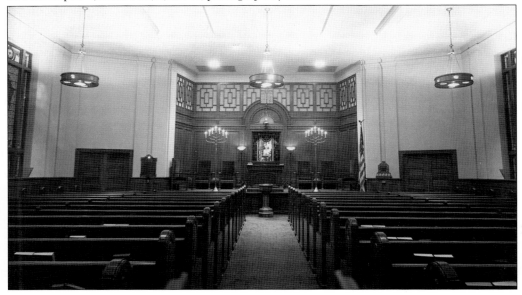

The 20th anniversary of Temple Beth Shalom ("House of Peace") on Allendale Road in Mechanicsburg in 1991 was the occasion for this photograph inside the synagogue's sanctuary. Seated from left to right are Rabbi Carl S. Choper, Rev. Charles Idler of Christ Presbyterian Church in Allendale (who extended use of the church for Friday-night services and Sunday school until the synagogue was built), and Morris and Lillian Kranzel. The temple was the first on the west shore of the Susquehanna River in the Greater Harrisburg area and was affiliated with the Reconstructionist Federation. Attracting 80 families, the congregation erected a synagogue in 1974 on land donated by Lillian Kranzel. Priding itself on its progressivism, the congregation welcomed "interfaith families, blended families, and individuals of all ages, races and sexual orientation" and was the first in the Greater Harrisburg area to hire a woman as rabbi with the appointment of Ilene Schneider in 1980.

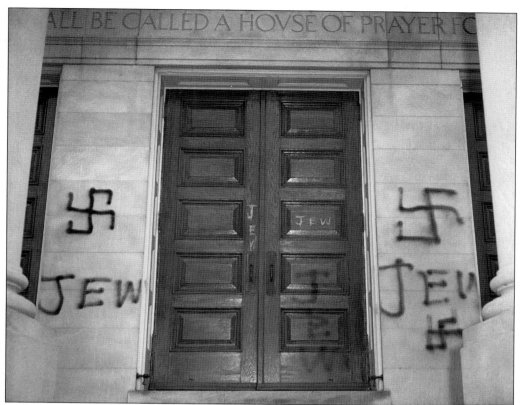

Central Pennsylvania was not immune to demonstrations of anti-Semitism, often displayed in vandalism to area synagogues. These photographs are of separate incidents in 1960 at Ohev Sholom (above) and in 1988 at Kesher Israel. Congregants at KI also found their synagogue desecrated with the slogan "Death to the Jews" in addition to the spray-painted warning for Jews to leave. Neo-Nazi and Ku Klux Klan rallies espousing anti-Semitic views were staged in Harrisburg and York during the 1990s. In 1998, police arrested four teenagers for plotting to shoot Jewish and black students in the Dover Area School District. In 2001, the neo-Nazi hate group Keystone United (formerly Keystone State Skinheads) formed in the Harrisburg area and staged public concerts. Groups including the UJC's Community Relations council (formed in 1961), Pennsylvania Jewish Coalition, Anti-Defamation League, and the Jewish Federation of Greater Harrisburg responded with tolerance outreach programs. (Right, courtesy Jewish Federation of Greater Harrisburg.)

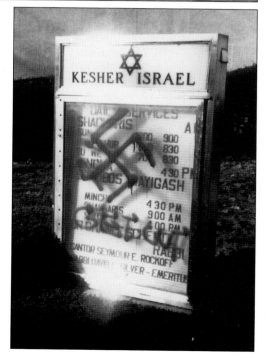

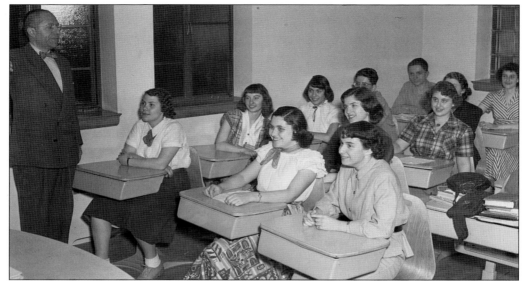

A backbone of Jewish education has been Hebrew school in the different synagogues. Pictured here is Rabbi Reuben Magill teaching students at Beth El Temple prior to confirmation services on June 10, 1951. In keeping with national trends, the conservative and reform synagogues after the 1950s geared their educational programs to preparation for bar and bat mitzvah and were challenged to retain students afterward. One solution employed by area synagogues with limited success was education toward confirmation, usually taking place at 16 or 18 years of age and held on the festival of Shavuot.

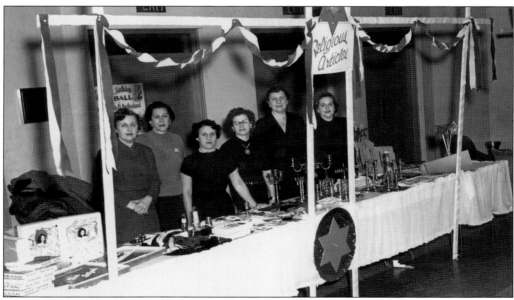

Sisterhoods of the synagogues often took the lead in sponsoring programming to extend religious practice and objects to the home. Pictured here is a Beth El Sisterhood display of Judaica in 1953. These events were precursors to the establishment during the 1950s of sisterhood Judaica shops where congregants could purchase religious and Jewish objects (especially Israel-themed objects) not available in department stores.

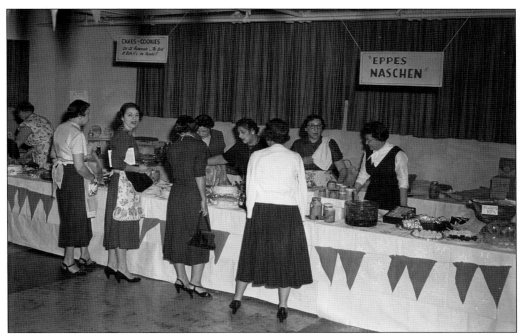

The synagogues in Harrisburg sponsored festive events to fuse social bonds among their congregants. Two longstanding traditions at Beth El Temple, both pictured here in 1955, were family night (above) and the George Washington Ball (below). The sign announcing *eppes naschen* (transliterated Yiddish for "something to nibble on" or a sweet snack) was a nod to the older, Yiddish-speaking immigrant generation that originally constituted the congregation.

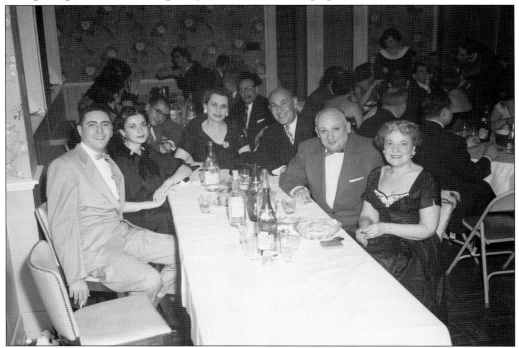

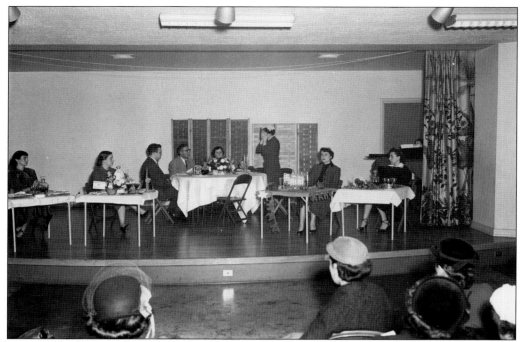

Synagogue sisterhoods staged adult education events to teach preparations for Shabbat and holidays; they also organized competitions for decorations and displays that contributed to the "Jewish Home Beautiful" movement, such as the ones pictured here at Beth El Temple during the mid-1950s for a Shabbat table and Hanukkah decorations. Below, Phyllis Lipsett hands honors for most beautiful to Charlotte Desaretz (left) and for most original to Edna Abrams (second from right).

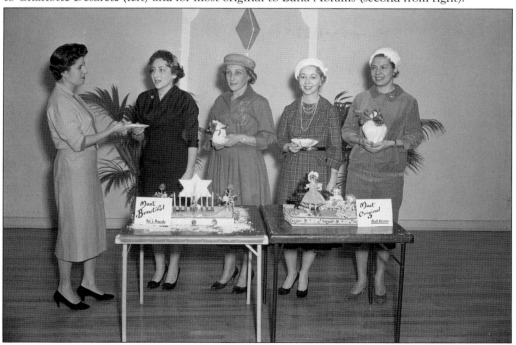

Rabbi Eliezer Silver, a driving force behind the Harrisburg Hebrew School (HHS) in 1920, wanted to connect programs across the spectrum of synagogues. Benjamin Lipsky (standing between two unidentified teachers in fourth at right) served as principal beginning in 1943, and his wife, Pninah (pictured below teaching Hebrew to first-graders in 1977), was a faculty member. Competition from synagogue Hebrew schools and the yeshiva pressured the school to dissolve after the principal's retirement in 1985. The robed graduating students shown from the class of 1950 are, from left to right, (first row) Ormond Urie, Sandra Cohen, Jane Yaverbaum, Gloria Marcus, Elaine Katz, and Herbert Press; (second row) David Bernstein, Warren Shore, and Hebert Stein; (third row) Larry Zuckerman, Norman Gittlen, and Jerry Cohen, with kindergarten teacher Sara Katz; (fourth row) unidentified, Lipsky, and unidentified.

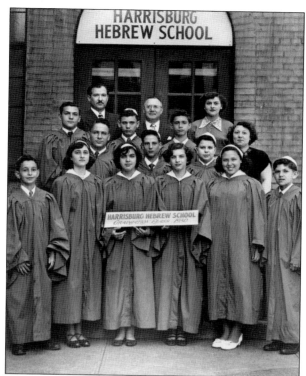

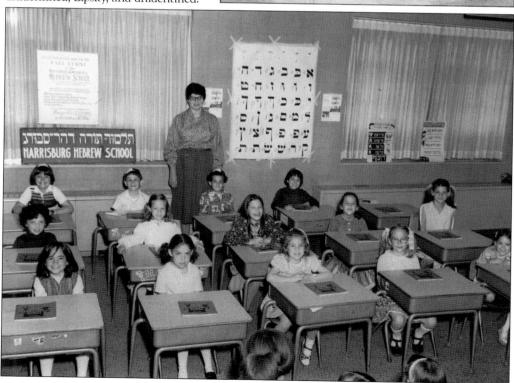

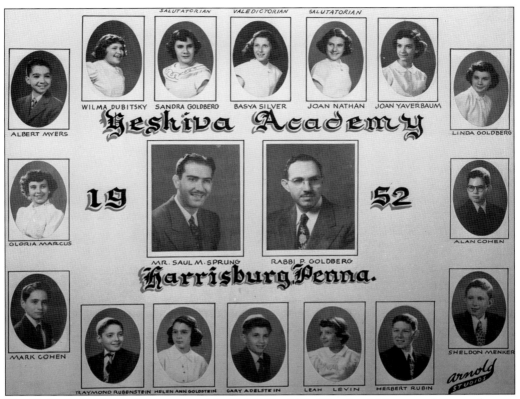

SALUTATORIAN VALEDICTORIAN SALUTATORIAN

WILMA DUBITSKY SANDRA GOLDBERG BASYA SILVER JOAN NATHAN JOAN YAVERBAUM

ALBERT MYERS

LINDA GOLDBERG

GLORIA MARCUS

ALAN COHEN

MR. SAUL M. SPRUNG RABBI P. GOLDBERG

MARK COHEN

SHELDON MENKER

RAYMOND RUBENSTEIN HELEN ANN GOLDSTEIN GARY ADELSTEIN LEAH LEVIN HERBERT RUBIN

Yeshiva Academy 1952 Harrisburg, Penna.

arnold STUDIOS

The Yeshiva Academy (later renamed for Rabbi David L. Silver), which opened September 11, 1944, was Harrisburg's first Jewish day school. It claims to be the first such school outside of a large metropolitan area. Credit for the establishment of the school is given to Rabbi David Silver and Aaron Feinerman, formerly principal of the HHS. The first class, made up of 11 first-grade boys, was housed in the JCC building. The following year, girls were added, and in 1952, girls outnumbered boys in Saul Sprung's third-grade class (above). In the photograph below taken in 1960, PTA members assisted faculty in organizing the new library.

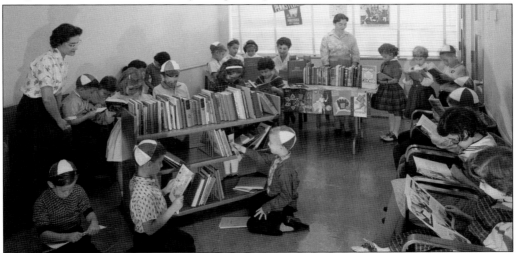

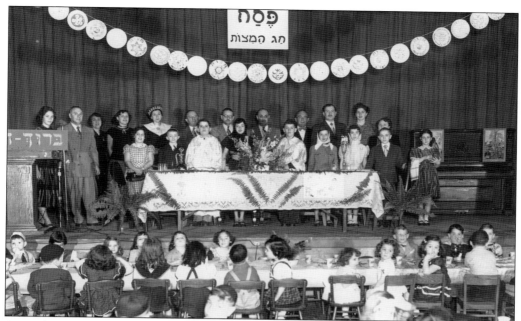

A popular annual program sponsored by the HHS was the model seder, also known as the children's seder, to prepare children at the JCC for home observance. On March 29, 1946, in the *Community Review*, HHS principal Lipsky underscored the social connections of the event when he wrote, "For the pupils it is a holiday experience of a communal nature; it brings the children together for an hour or two of fellowship thereby helping to make them a closer part of the community school." This photograph was taken in 1951.

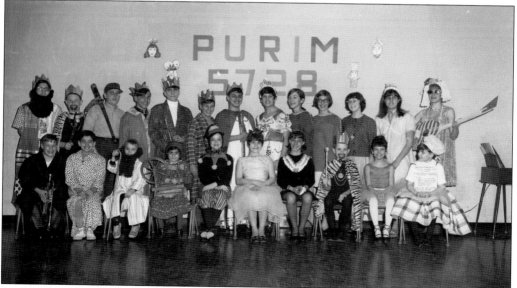

In this photograph taken at Chisuk Emuna in the Hebrew year of 5728 (March 1968 in the modern Julian calendar), children celebrate Purim in traditional (Queen Esther, King Ahasuerus, and palace official Mordecai) and nontraditional outfits (baseball player, rock star, ballerina, and colonial-era spinner).

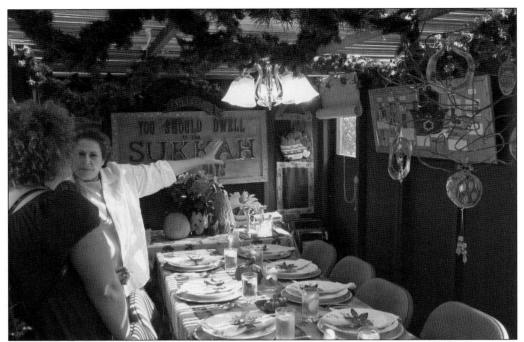

Marian Frankston explains the decorations in her sukkah to visitors during the annual Sukkah Hop in the uptown section of Harrisburg. The event is based on the custom during the traditional harvest festival of offering hospitality to guests who do not have a sukkah of their own. (Photograph by Simon Bronner.)

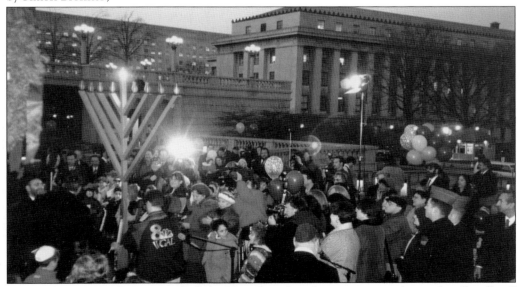

With its location in the state capital, the Harrisburg Jewish community is featured in "kindling" an electric Hanukkah menorah at the Capitol's East Wing Plaza. At this event in 1998, Gov. Tom Ridge participated in the ceremony, lighting the *shamash*, the center candle of the menorah, with the help of Harrisburg rabbi Shmuel Pewzner of Chabad Lubavitch, sponsor of the public celebration. (Courtesy Jewish Federation of Greater Harrisburg.)

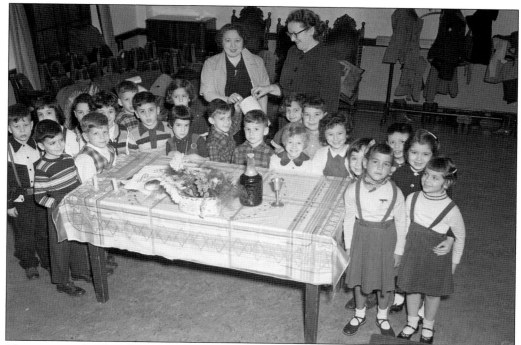

The nursery school at the JCC is pictured here in 1955 learning about shabbat. Early childhood care and education expanded by the early 21st century to divisions at the early learning center for infant and toddler care, preschool, minicamps, after-school care, and Kinderplace, an afternoon enrichment program for children who attend a morning kindergarten.

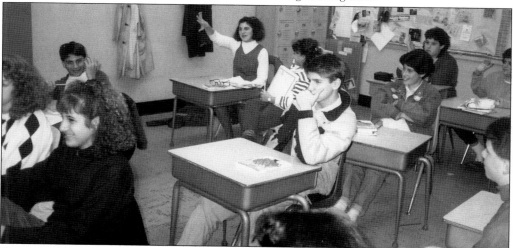

Concerned for continuing Jewish education for teenagers past the bar and bat mitzvah years, area Jewish congregations and the United Jewish Community established the UJC High School for Jewish Studies in 1967 (later renamed Harrisburg Hebrew High). In this photograph from 1988, students discuss Jewish issues in the national election. Other popular programs included Hebrew calligraphy, creative Judaic arts, Jewish journalism, and Holocaust literature. A special orientation of the high school program for many years has been social justice service learning opportunities. (Courtesy Jewish Federation of Greater Harrisburg.)

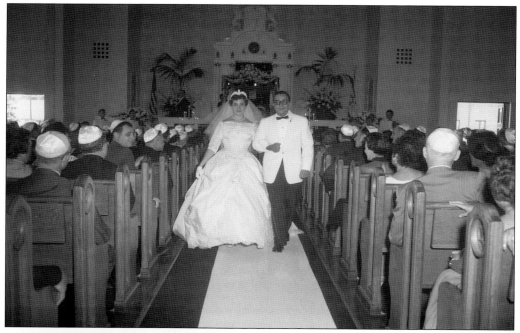

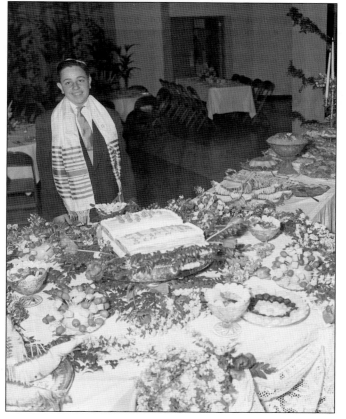

Arnold Zuckerman photographed the wedding of Gary Spitz (1936–2006) and Charlotte Stein at Kesher Israel in 1960. Spitz worked in the garment industry and became active in both Harrisburg and Jewish community civic affairs, including serving as Susquehanna Township commissioner, executive director of the JCC (1991–1997), and a KI board member.

The bar mitzvah took on increasing importance as a celebration in Harrisburg and other American cities after the 1950s, despite the ambivalence of many rabbis about the cultural attention given to the event. Pictured here in 1951 is Melvyn Finkelstein's bar mitzvah held in a rented hall with the characteristic catered kosher food spread and Torah cake.

Three

THE CENTER, COMMUNITY, AND FEDERATION

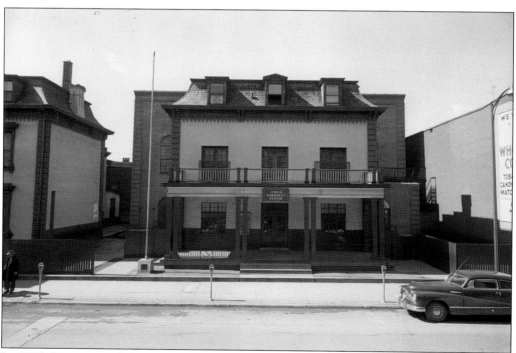

In 1915, formation of the Y was undertaken by Louis Brenner, a state representative of the National Council of Young Men's Hebrew and Kindred Associations, and Jewish civic leader Leon Lowengard, who became the Y's first president. After leasing a house for its programs, the Y moved into expanded facilities at 1102 North Third Street before occupying the above building at 1110 North Third from 1931 to 1958, when the JCC building was erected uptown.

Albert Hursh (1914–2004) worked at the JCC and the UJC for over 70 years. The son of Russian immigrants operating a secondhand clothing store on Aberdeen Street in Harrisburg, Hursh began working in 1933 at the "old Y." In 1939, he became administrative assistant, and in 1951, he was named executive director of the JCC and UJC. (Courtesy Jewish Federation of Greater Harrisburg.)

Gustav "Gus" Kaplan was the first president of the UJC and held the executive position from 1933 to 1942. In keeping with the Roosevelt era in which it was founded, the UJC was described in an announcement as a "New Deal" in Jewish communal and philanthropic activities; the organizational structure for a Jewish communal agency drew national attention as the Harrisburg Plan. (Courtesy Jewish Federation of Greater Harrisburg.)

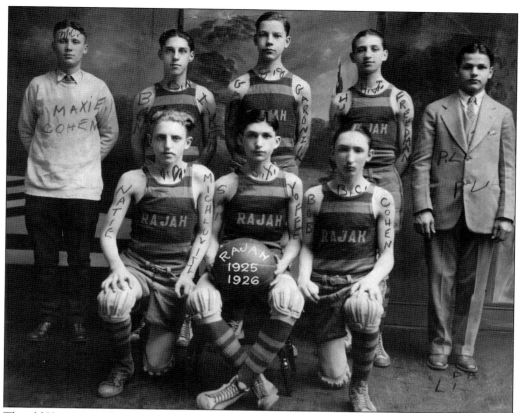

The old Y was intended to be community wide, offering recreational opportunities for both children and adults and providing common ground for members from different wings of Judaism. Two examples of programming from the 1920s are the "Business Men's Gym Class" taken in the Y's gym in February 1928 and a Jewish basketball team from the 1925–1926 season. Basketball team members' names are written on the photograph above, from left to right: (first row) Natie Michlovitz, Sam Yoffe, and Bob Cohen; (second row) Maxie Cohen, Ben I-Kin, Gary Garonzik, Hun Freedman, and P. L. A year-round sport that required relatively minimal investment in equipment for immigrants, basketball was the most popular participant sport among Jews. (Courtesy Jewish Federation of Greater Harrisburg.)

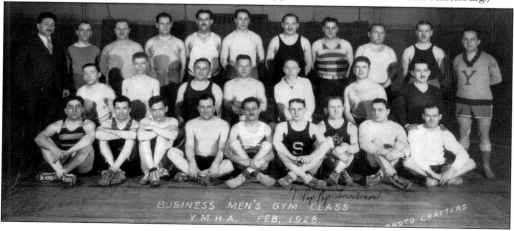

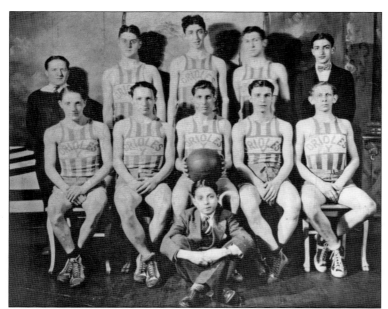

A Jewish team called the Orioles won the 1927 Harrisburg city championship. Team members are, from left to right, (first row) Hyman Michlovitz, Billy Michlovitz, Charles Gerber, Philip Newmark, Elle Gerber, and on the floor, mascot Moe Furman; (second row) coach Micky Michlovitz, Harvey Meltzer, Jac Lehrman, Hyman Gerber, and Arthur Lack. (Courtesy Jewish Federation of Greater Harrisburg.)

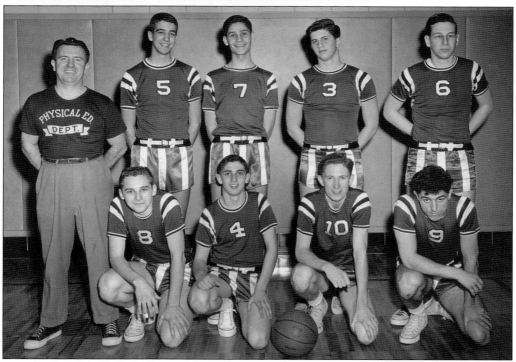

Harrisburg Jewish teams vied with other units in the region to participate in national tournaments. After defeating a team from Allentown in 1958, the Harrisburg teenage basketball team pictured here earned the right to play in the Final Four of the National Jewish Welfare Board Tournament held in Springfield, Massachusetts—the birthplace of basketball. Pictured here, from left to right, are (first row) Hirsch Anservitz, Eddie Lyons, Sheldon Menker, and Allan Apple; (second row) coach Dick Yingling, Buddy Menaker, Harold Ronen, Gary Adlestein, and Herb Rubin.

Joseph Alexander, pictured at right, served as president of the JCC from 1925 to 1932 and continued to serve on the board after he stepped down. Charles Feller, below, had several leadership posts, including the presidency of the JCC from 1934 to 1936, treasurer of the UJC in 1950, and general chairman of the 1951 and 1958 UJC fund drives. Born in Romania, Feller (1879–1967) came to the United States in 1900 and moved to Harrisburg in 1922 to set up a retail clothing shop after working in New York City. He expanded the nine-story building at 301 Market Street and renamed it the Feller Building. He was also active in the Israel Bonds Drive and the Jewish National Fund (JNF), serving as chairman of the JNF Council of Harrisburg and treasurer for its Penn Seaboard Region during the 1950s.

Community Review

Volume 8 NOVEMBER 1933 Number 1

Feature Editorial

The Jewish Arbitration Court

The Community Review takes this opportunity to congratulate the Salem Lodge of the B'nai Brith for their unselfish communal spirit in the establishment of a Jewish Court of Arbitration.

Fundamentally, the Jewish Court, which has behind it the historical weight of the Sanhedrin, of the judges who thousands of years ago administered the law and ruled over the Children of Israel, is a court of conciliation. It attempts to satisfy both sides, rendering justice and simulataneously appeasing the loser. Aside from financial claims it fulfills a larger purpose—that of understanding the woes of a race which carries on in a modern world racial traditions and religious customs that are thousands of years old.

In our community we have most fortunately been spared to a very great extent the spectacle of two Jewish litigants appearing in our local courts and subjecting themselves, as well as our old and honored traditions and customs, to public ridicule. Nor could the Nordic members of the judiciary, not knowing the differences between a talis and a toothpick, intelligently render justice were a question of distinctly and peculiarly Jewish nature involved. They are as much befuddled by the psychology of the Jewish race as by its terminologies.

The aim of the court is to carry out the Jewish ideal of justice simply and directly without the encumbrance of complicated procedure and without the unpleasant publicity which accompanies court trials.

The people at first will probably be skeptical of such a court, but with proper publicity and particularly by assigning as judges men of unimpeachable reputation for justice and fair dealing, litigants will be encouraged to avail themselves of this splendid service, not only for religious and organization disputes and minor differences, but also for disputes involving substantial interests.

The judges of the first Jewish Court of Arbitration for Harrisburg have been announced as follows: Joseph Garner, Morris E. Jacobson and Henry Brenner. It is with absolute assurance that we envision the greatest respect for and impartiality of the court with judges of the sterling character of these men.

The court will render an unique service to the Jewish community, to the city and to the state.

Record Crowd to Attend Annual Thanksgiving Ball

Fourteenth Annual Affair to Feature New Novelties and Surprises

The Annual Thanksgiving Ball, to be held at the Jewish Community Center on Thursday evening, November 30th, has been the outstanding social event of our community for the past fourteen years, and this year the Ball promises to be even bigger and better than ever. Miss Martha A. Lehrman, publicity chairman, assures us that Mrs. Herman Dietch, general chairman of the dance, and her several committees are leaving no stone unturned to make this year's dance the finest yet.

The program committee, consisting of Maurice Yoffee, Louis Cohen, Mrs. Philip Golumbic, Mrs. Gustav Kaplan and Lilyon Kleinman, have arranged novel entertainment that is sure to please even the most critical. If you doubt the committee's statement, come to the Ball and see for yourself.

The ballroom will be beautifully decorated with palm trees, making a truly Southern atmosphere, a veritable night spent in the warmth and color of Miami. These elaborate decorations are the thought and works of the following committee: Dr. Paul Zuckerman, Richard Solomon, Irvin Danowitz, Mrs. Joseph Levinsohn and Mrs. Simon Brenner.

As you may have noticed, these committees are made up of representatives of each of the senior organizations in the Jewish Community Center, for this dance is essentially a united Jewish effort that is supported by all. Among those organizations participating are the Avodah Club, Sigma Alpha Rho, Junior Y, Senior Y and Junior Hadassah.

Macey E. Klein, Sara Silberman, Rose Michlovitz, Louis Fisher, Joseph Levinsohn and Ida Hurwitz are in charge of the sale of tickets. They will be pleased to accommodate you.

Ted Brownagle, Harrisburg's reigning favorite for "tripping the light fantastic" will furnish the music. With Ted the master of the baton, we can be certain that the brand of music will be excellent. Ted's boys are versatile, and besides playing the music you delight to hear, will entertain throughout the course of the evening. The inimitable McCarthy at the bass viol is worthwhile watching—if he cannot make you chuckle at his antics and at his joyous capers, then, believe it or not but, you must be a cynic.

(Continued on Page 2)

U. J. C. Elects Officers and Appoints Standing Committees for Year

A final organization meeting was held by the United Jewish Community on Tuesday evening, November 14th, for the purpose of electing officers and appointing committees. This organization is a forward step in philanthropic work in the community—replacing the work of the Federation of Jewish Philanthropies—including in its program a wider scope of activities.

A financial report of the campaign was read to those present. The officers elected at the meeting are as follows: Gus Kaplan, president; Malcolm Ulman, vice-president; Joseph Levinsohn, secretary; Jacob Miller, treasurer, and Paul Goldblatt, executive director.

The chairmen of the standing committees are: Henry H. Brenner, local affairs; Samuel Brenner, membership; Mrs. Gus Kaplan collections; Joseph Garner, budget and finance; Samuel Finkelstein, national and international affairs; Nathaniel Bernstein, educational and cultural.

The United Jewish Community offers literally a "new deal" in Jewish communal and philanthropic activities. The new organization includes the Jewish Community Center, the Harrisburg Hebrew school, the Hebrew Sheltering

(Continued on Page 2)

A Community Paper

The first issue of the Community Review is now in your hands. This year we will bring to you more complete news of what has taken place and what is going to take place in the Harrisburg Jewish community.

Heretofore the Review was a Community Center organ exclusively, now it is a publication that will embrace all news of Harrisburg Jewery. All active Jewish organizations in the city which have news of interest to the community are asked to send it to the Community Review in care of the Jewish Community Center. It is the endeavor of the staff to make this year's Review reflect a true cross-section of Jewish life in the city of Harrisburg.

The front page of the November 1933 *Community Review* announced that the issue was the first to be a community-wide news organ. The publication began in 1926 as a newsletter of Y activities. In conjunction with initiating a UJC umbrella organization that same year, the new four-page monthly magazine format was intended to create "A Community Paper," one that was "a true cross-section of Jewish life in the city of Harrisburg." The featured story in this issue was the annual Thanksgiving ball at the Y, described as "the outstanding social event of our community for the past fourteen years." (Courtesy Jewish Federation of Greater Harrisburg.)

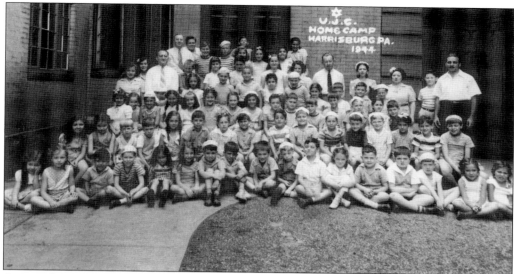

Among the new programs initiated by the UJC was one for children's summer camping, beginning in 1939. It had tripled its size by the time this photograph was taken in 1944. The Home Camp was so-called because it was located in the center's courtyard on Third Street in the city. Sidney Lustig, physical education director at the community center, directed the camp program. The photograph below shows the children and staff of the 1955 Center Day Camp. Seeking greener pastures for urbanized Jewish children, the Home Camp later moved to a larger site on a farm in Susquehanna Township called Hagy's, allowing for expanded participation, before acquiring Green Hills Swim Club in the Fishing Creek Valley north of Harrisburg. (Courtesy Jewish Federation of Greater Harrisburg.)

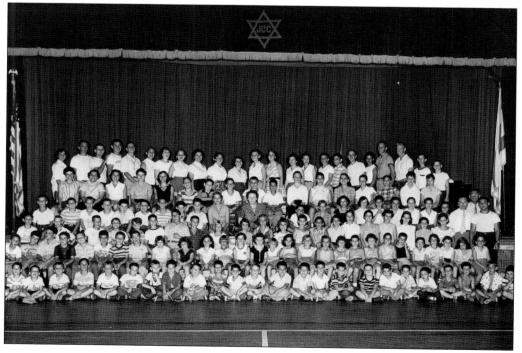

The JCC welcomed back Jewish veterans of World War II in a dinner-dance pictured here on October 27, 1946. The JCC organized a Veterans Service Committee, chaired by Joseph Garner, to assist the veterans. Many of them joined Post 97 of the Jewish War Veterans and on November 12, 1945, participated in the Armistice Day parade to a warm welcome in downtown Harrisburg. (Courtesy Jewish Federation of Greater Harrisburg.)

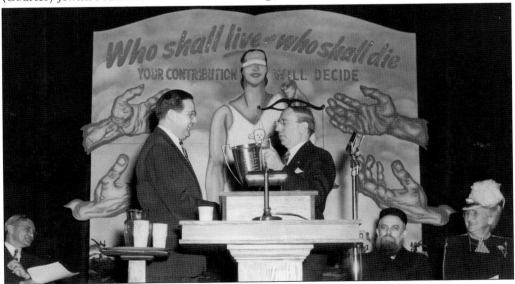

Aaron Feinerman, chairman of the advanced gifts division, receives the loving cup for service from Rabbi Philip Bookstaber, general chairman of the 1946 campaign at the General Community Assembly, April 10, 1946. With the memory of the war fresh in their minds, campaign leaders used military rhetoric to mobilize "the army of volunteers who will constitute the Harrisburg Battalion of Mercy in our effort to deliver the remnant of European Jewry." (Courtesy Jewish Federation of Greater Harrisburg.)

Mary Sachs, 1947 UJC campaign general chairwoman, hands the loving cup to Joseph F. Brenner, 1948 general chairman, for his service. The UJC earmarked funds for European World War II survivors and local needs: JCC, HHS, Transient Home (located at 637 Boas Street), Hebrew Ladies Aid Society (aimed at Jews with disabilities), and Free Loan Fund (providing short-term assistance for families and businesses). (Courtesy Jewish Federation of Greater Harrisburg.)

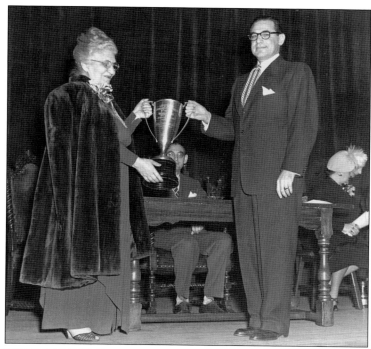

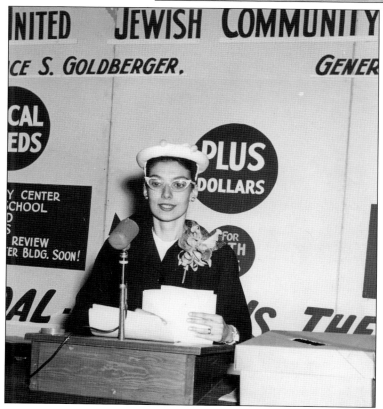

At a 1956 UJC fund-raiser, Shirley Spector Garner (later Freedman) was introduced as division head for an appeal to young Jewish women. Active in various charitable organizations throughout her lifetime (1928–2001), she later served as president of Hadassah's Harrisburg chapter, the Jewish Home, Beth El Temple board, and the Tri-County Mental Health Association. (Courtesy Jewish Federation of Greater Harrisburg.)

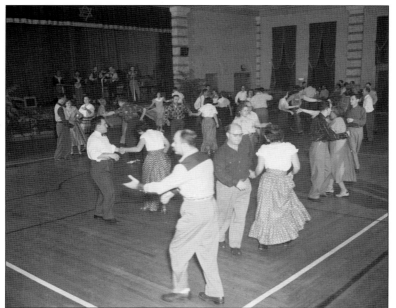

In addition to engaging in sports, JCC members enjoyed square dances in the early 1950s, as folk and western fever caught on nationally in films, music, and dance. In this picture taken in the fall of 1951, organizers tied the Jewish harvest festival of Sukkot to the American image of a barn dance after the harvest in the advertisement for a sukkah square dance.

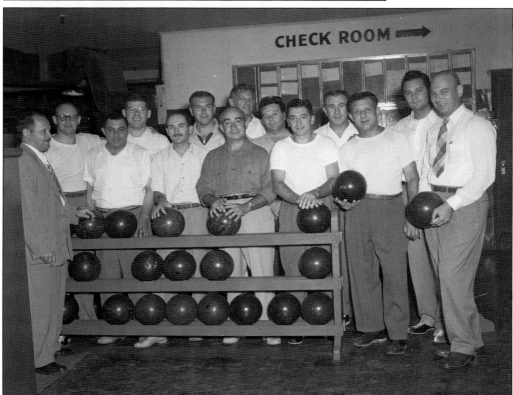

Captains of the JCC bowling league are shown in September 1952 with JCC president Dr. Mortimer Menaker (far right). The popularity of bowling during the 1950s led to the installation of lanes in the new uptown JCC.

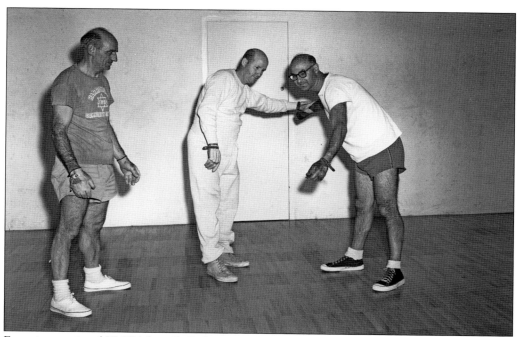

Four-time national YMCA handball champion Stan Hitz demonstrates techniques at a handball clinic to Max Shore (left) and Eddie Heit (right) in preparation for the 1958–1959 season. The JCC had a four-team handball league organized by Herman Krevsky in its new courts.

Irving Yaverbaum served as UJC president from 1950 to 1952. Outside of work at his accountancy firm, he was involved in leadership for Kesher Israel, Beth El Temple, and the yeshiva. In addition to servicing the needs of young families in the postwar baby boom, his UJC board had the challenge of responding to a self-study showing a shift of the Jewish population uptown to the 10th Ward between Maclay and Division Streets (42 percent lived there); the old Y was located in the Fifth Ward, where only six percent of the Jewish population resided.

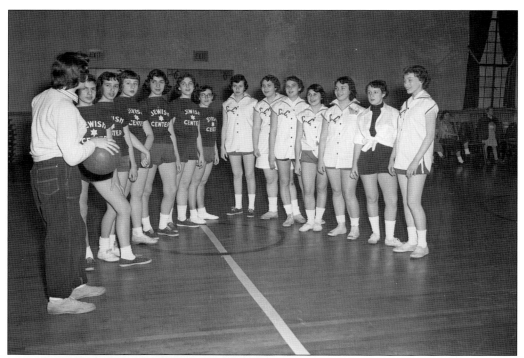

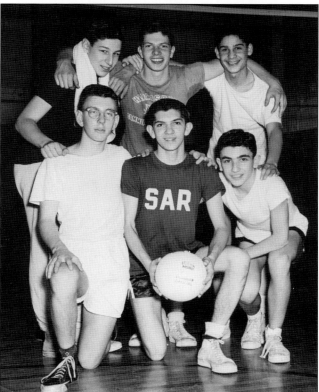

The JCC took a lead among Harrisburg gyms in sponsoring competitive women's athletics, including the varsity basketball team pictured here in February 1953. Other JCC-sponsored women's sports included volleyball and fencing.

Playing on the resumption of the Olympics after World War II, the JCC sponsored athletic "Olympiads." The games featured fierce competition among Harrisburg Jewish fraternities, but Sigma Alpha Rho, pictured here, emerged victorious in volleyball. This group consists of, from left to right, (first row) Herb Nurick, Herb Press, and Jerry Brenner; (second row) Herb Rubin, George Krevsky, and Hal Ronen. In the next decade, an adult volleyball league met regularly on Sunday mornings in the JCC gym. (Courtesy Herb Press.)

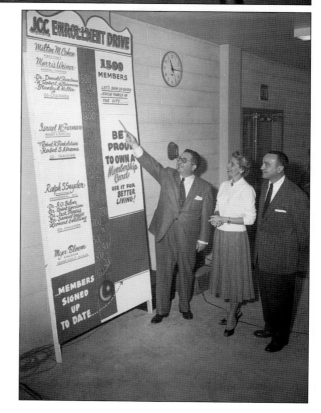

Jay Maisel (left), chairman of the JCC's special activities committee, and Herbert J. Brenner, chairman of the adult program committee, register teens for its innovative leisure time program in October 1955. The program addressed a growing community's demands to supplement athletic programs with arts, dance, and music classes for different age groups.

Israel M. Furman, chairman of the JCC's membership and sustaining divisions, points to a membership thermometer at a kickoff breakfast in December 1957. Attentive to the goal of adding members as Harrisburg's Jewish community expanded in the post–World War II baby boom are Selma Finkelstein and Herbert S. Abrams. The UJC estimated that Harrisburg's Jewish population had risen from a 30-year low of 3,000 in 1945 to 5,500 in 1960, an increase of over 83 percent, mostly gained during the 1950s.

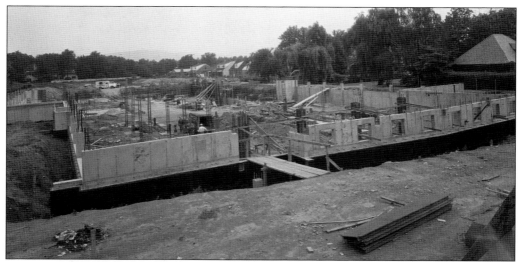

A building committee chaired by Henry H. Brenner worked with Harrisburg architect William Lynch Murray (1903–1982) in the mid-1950s on the design of the new uptown JCC. Leaders touted a separate gym and auditorium to replace the multipurpose space of the Third Street Center. The committee also unveiled plans inside for a pool, health spa, lounge and library, classrooms, game room, and a parking area—especially important in deference to the rise of automobile culture and suburbanization. Murray, known for his sharp vertical lines on the State Street building and Paxton firehouse from the 1930s, applied sharp angles again, but oriented the building to stretch with its long side parallel to the river in an apparent nod to the unornamented appearance of the international style that had become all the rage among modernist architects. The above photograph shows progress of the center's construction and the bucolic surroundings of the area (Interstate 81 had not been built yet) four months later. Arnold Zuckerman photographed the completed edifice shown here in December 1957, but the entrance drive on the left had not yet been paved.

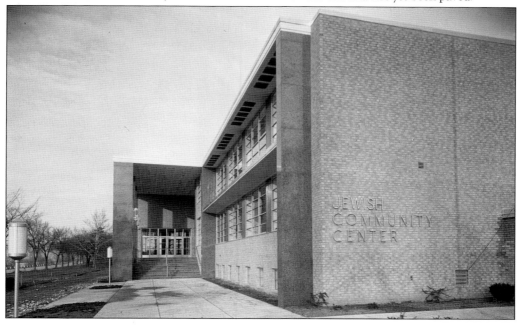

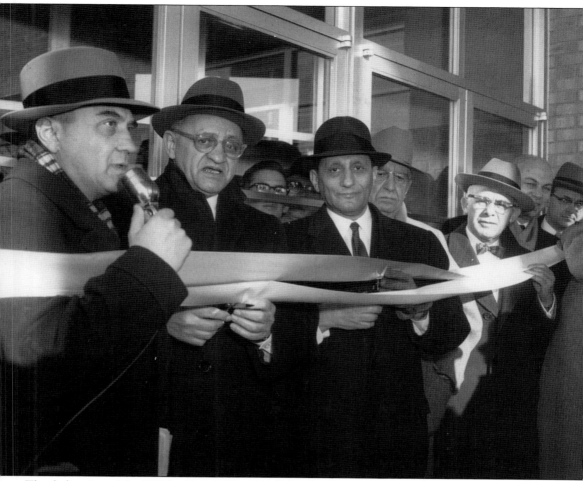

The dedication of the JCC building at Front and Vaughn Streets occurred on Sunday, January 19, 1958. It began with the ribbon-cutting ceremony pictured here. From left to right are dedication chairman Solomon Hurwitz (holding the microphone), Henry H. Brenner (chairman of the building committee), and Milton M. Cohen (president of the center). To the right of Cohen behind his shoulder is Louis Lehrman, who received the honor of attaching the mezuzah to the doorpost (another tribute was naming the JCC pool for him). Past presidents of the JCC lined up behind the ribbon, including Louis Fisher (1940–1941) and Mortimer Menaker (1952–1954), who are to the right of Lehrman. After the ribbon-cutting, the chilly January crowd went inside for a program in the auditorium. That evening was hailed as "Family Night" featuring comedy by television star Betty Walker, who regularly appeared on *The Goldbergs*, *Milton Berle Show*, and *Garry Moore Show*. The weeklong festivities culminated with a grand ball and dedication banquet including dramatic skits depicting the history of the JCC and dancing to the music of local Jewish bandleader Al Morrison.

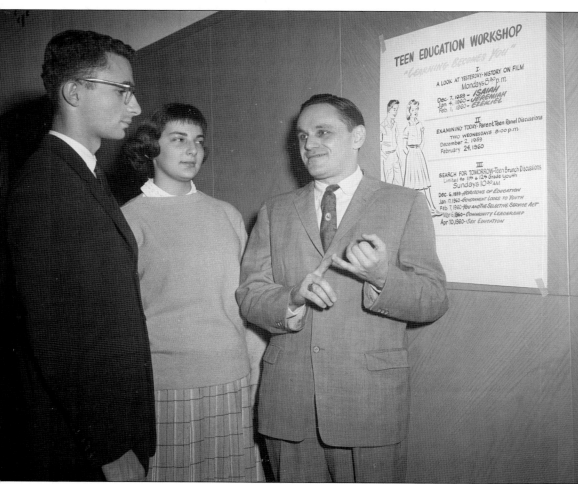

By the end of the 1950s, the JCC added programs for its growing population of teen baby boomers. This photograph shows one such program titled "Teen Education Workshop: 'Learning Becomes You,' " running from December 1959 to April 1960. Amid concerns for "juvenile delinquency" and rebellious youth, the program promoted "Parent-Teen Panel Discussions" devoted to "Examining Today." The program culminated with timely "teen brunch discussions" about the military draft, community leadership, and sex education. Ohev Sholom rabbi Hillel A. Fine is shown making points to teens Richard Miller and Barbara Danowitz.

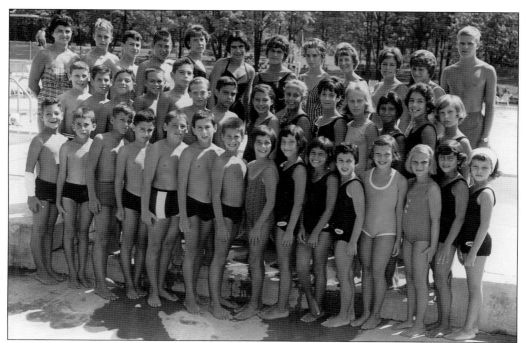

The group shot from the early 1960s is of the swim team at Green Hills Swim Club, a JCC facility, in the Fishing Creek Valley northeast of Harrisburg. The overhead shot of the pool at Green Hills is dated 1959. The JCC later added sports and craft facilities to the complex, including basketball, volleyball, and "Ga-Ga" (see page 56) courts beyond the fence on the left.

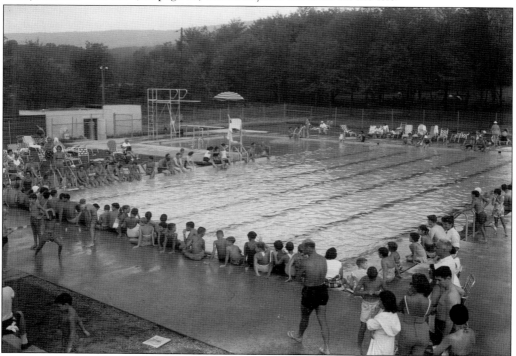

The JCC softball team played in snazzy uniforms on fields in Wildwood Park during the 1950s and competed in an industrial league. Decades later, after the fields were gone as a result of development in that part of the city, Sunday pick-up play shifted to Green Hills and nearby parks.

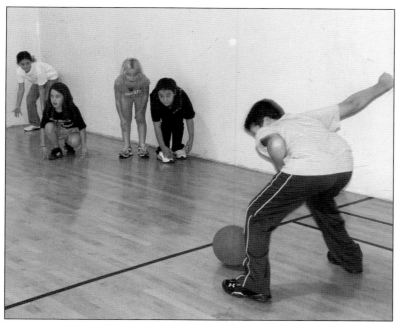

Taking hold in the late 20th century at the JCC day camp in Green Hills and in tournaments held at the JCC was Ga-Ga (sometimes called Israeli dodgeball), an elimination game played with a rubber ball. The game is played in an enclosed space like the handball court pictured here or in a wooden pit like the one built at Green Hills. (Photograph by Simon Bronner.)

Community
OFFICIAL ORGAN OF THE JEWISH COMMUNITY CENTER
REVIEW
PUBLISHED BY THE UNITED JEWISH COMMUNITY OF HARRISBURG
100 Vaughn St., Hbg., Pa. SINGLE COPY 5c
Second Class Postage Paid at Harrisburg, Pa.
Return Postage Guaranteed

Vol. 42, No. 3 HARRISBURG, PA., SEPTEMBER 29, 1967 Elul 24, 5727

UJC

A man who has committed a mistake and doesn't correct it, is committing another mistake!

Merlin Rappaport	Mrs. Irwin Benjamin	Sidney Slotznick	Morton Spector	Alexander Grass
President	President	President	General Chairman	General Chairman
Hebrew School	Jewish Community Center	United Jewish Community	1967 U.J.C.A. Drive	Israel Emergency Drive

WE TOOK A GIANT STEP!

WE TOOK A GIANT STEP IN ANSWER TO A MONSTROUS SITUATION! IMMEDIATELY FOLLOWING A SUCCESSFUL U. J. C. A. CAMPAIGN, OUR COMMUNITY RESPONDED WITH SPONTANEITY, SOLIDARITY AND STRENGTH TO A MIDDLE EAST EXPLODING IN VIOLENCE, THREATENING THE VERY EXISTENCE OF ISRAEL.

THE OUTPOURING OF GENEROSITY CAPPED ANY PRIOR EXPERIENCE IN A LONG HISTORY OF GENEROUS GIVING. HARRISBURG RAISED $1,144,000! WE WERE A COMMUNITY COALESCED IN COMMON CAUSE.

EVERY SECTION OF THIS COMMUNITY PLAYED A PART IN THE QUIET BATTLE TO MAINTAIN THE PHILANTHROPIC PROGRAMS WE HAVE HELPED TO BUILD AND SUPPORT THROUGH THE U. J. C. A. AND TO BOLSTER THE BATTERED ECONOMY OF BELEAGUERED ISRAEL THROUGH THE ISRAEL EMERGENCY FUND.

ONLY PEACE CAN BRING AN ULTIMATE SOLUTION TO THE ENIGMA OF MIDDLE EAST EXISTENCE, AND UNTIL IT IS ACHIEVED, OUR EFFORTS MUST CONTINUE UNABATED ON THE ECONOMIC AND PHILANTHROPIC FRONTS.

THIS EXPERIENCE HAS BEEN HISTORIC IN ITS HUMANITARIAN ASPECTS. ALL WHO PARTICIPATED HAVE A RIGHT TO FEEL DEEP PRIDE IN WHAT HAPPENED IN ISRAEL AND WHAT HAPPENED IN HARRISBURG. THERE IS STILL MUCH TO BE DONE BUT CERTAINLY WE KNOW WE CAN DO IT!

Albert Hursh
Executive Director

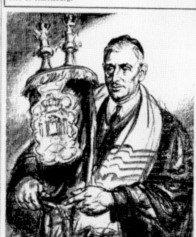

Ben Edelman
Assistant Ex. Dir.

"OMNIBUS SERIES"
on planning board!

Morton Spector (top, second from right) was general chairman of the United Jewish Communities Appeal (UJCA) drive when war broke out in the Middle East in June 1967. Responding quickly, the groups organized an Israel Emergency Drive with Alex Grass as chairman (top right). Working with the national leadership of the United Jewish Appeal (UJA), Harrisburg's Jewish community was credited with having the highest per capita donation in the United States to the organization's emergency fund during the Six-Day War. The community again made a strong showing of emergency support for Israel in 1973 after the Yom Kippur War, more than doubling its previous total. (Courtesy Jewish Federation of Greater Harrisburg.)

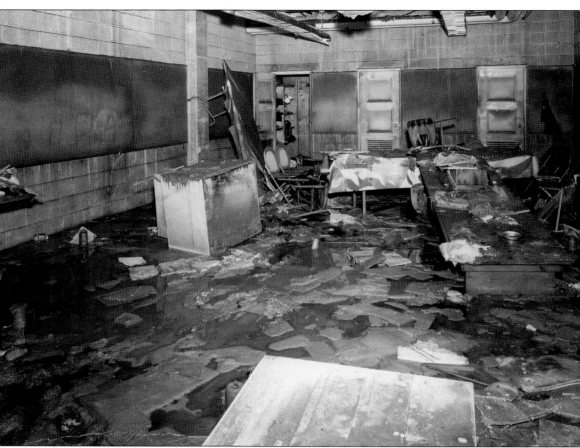

Heavy rains from Hurricane Agnes in June 1972 caused flooding from the Susquehanna River that devastated the JCC. Shown in this photograph is the damage to the arts-and-crafts room after the waters had receded. In a front-page editorial titled "Meeting the Challenge" in the September 8, 1972, *Community Review*, community leaders complimented the Jewish community for lending "assistance, in the grandest manner conceivable"—getting in the muck and picking up debris. The editorial also extended gratitude to neighboring Mennonites and Amish for their "laborious assistance." The JCC did not return to full operation until January 1973. (Courtesy Jewish Federation of Greater Harrisburg.)

In 1989, Nancy Cramer (later Aronson) became the second woman in the JCC's history to be elected its president. The first was Roslyn Benjamin (1920–2005), who served from 1966 to 1968. Cramer entered into leadership at a time when the Jewish population in the Greater Harrisburg area exceeded 10,000 for the first time in the community's history, and new infusions of immigrants from Russia and Israel were part of the social mix. (Courtesy Jewish Federation of Greater Harrisburg.)

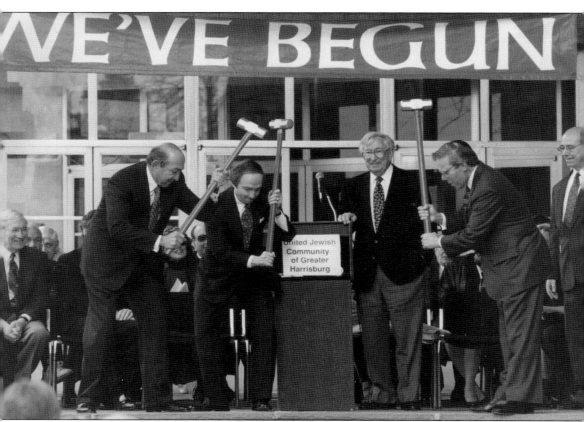

In 1995, the UJC launched a $9 million fund drive for renovation and expansion of the existing facility into a multi-building Jewish community campus. Shown here inaugurating the project are, from left to right, Alex Grass, Allan Noddle, Moses Rosenberg, and Burton Morris, with UJC executive director Jordan Harburger looking on at right. (Courtesy Jewish Federation of Greater Harrisburg.)

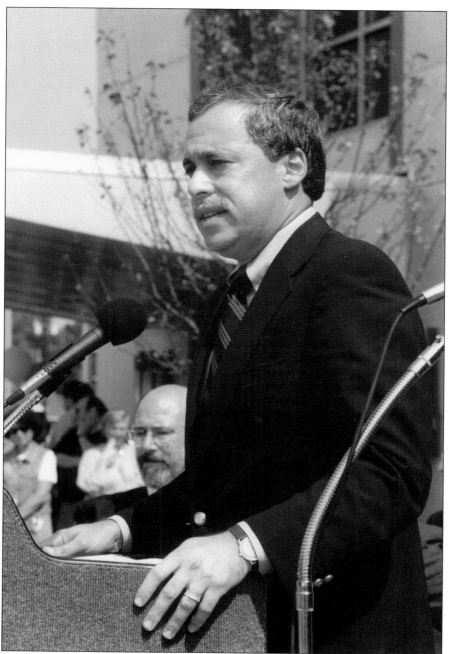

UJC president Harvey Freedenberg addresses the crowd at the dedication of the renovated JCC in this photograph from 1996. Freedenberg led the community as chairman of the UJCA campaign (1992–1993), long-range planning committee (1997–1999), community relations council (1984–1991), and *Community Review* editorial board (2000–2007). He also served on the boards of other Jewish institutions, such as the Jewish Group Home, Yeshiva Academy, and Beth El Temple. He was honored with the David Javitch Young Leadership Award (1989) and the Albert Hursh Senior Leadership Award (2007). (Courtesy Jewish Federation of Greater Harrisburg.)

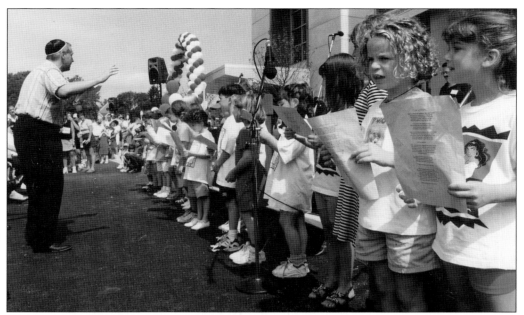

Children perform at the dedication of the newly named Harriet and Jeanette Weinberg JCC on the multi-building Alex and Louise Grass United Jewish Community Campus on September 8, 1996. They are lined up in front of the remodeled entrance and lobby area on the Front Street side; previously the main entrance had been on Vaughn Street. (Courtesy Jewish Federation of Greater Harrisburg.)

A sign at the new entrance to the JCC advertises the fitness center located on the lower level of the building. The structure around the new lobby stands in contrast to the design on the length of the building. The path on the left goes to a new playground facility for the early learning center. The sign by the path announces the Lily Herman Kinder Garden, named for a former teacher at the yeshiva. (Photograph by Simon Bronner.)

Four

ORGANIZATIONS, MEMORIALS, AND MITZVOT

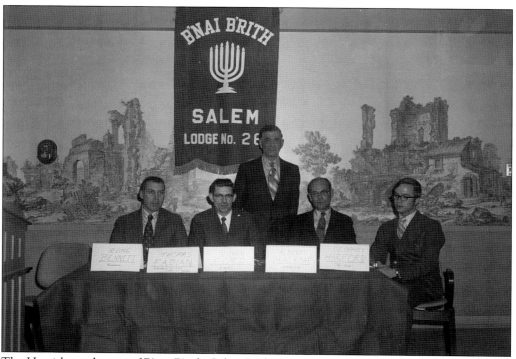

The Harrisburg chapter of B'nai B'rith, Salem Lodge No. 26, received its charter on February 24, 1856. A service-oriented organization, the Harrisburg chapter had a host of subgroups, including B'nai B'rith Women, B'nai B'rith Girls, B'nai B'rith Youth Organization (for teens), and the male fraternity Aleph Zadik Aleph. Pictured here during the 1950s is a panel moderated by Irving Bennett (standing) on college scholarships.

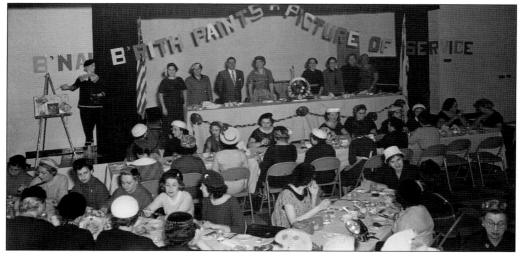

"B'nai B'rith Paints a Picture of Service" was B'nai B'rith Women's theme for the organization's kickoff of the 1957–1958 year. Activities included a citizenship essay contest for high school students, rummage sale to raise funds for philanthropies, service to hospitals, vocational guidance, outreach to Jewish college students in the region, and tolerance education.

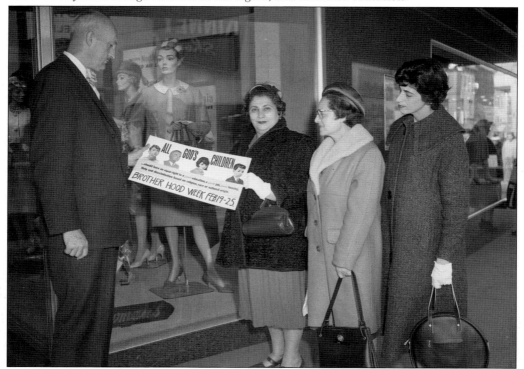

Members of B'nai B'rith Women distribute posters during the civil rights movement in this photograph taken in 1961 in front of Bowman's Department Store at 314 Market Street in Harrisburg. The sign promotes Brotherhood Week. The poster shows children of different colors and a text reading, "All God's Children . . . should have an equal right to a good education, a good job, good housing. Help end discrimination based on religion, race, or national origin."

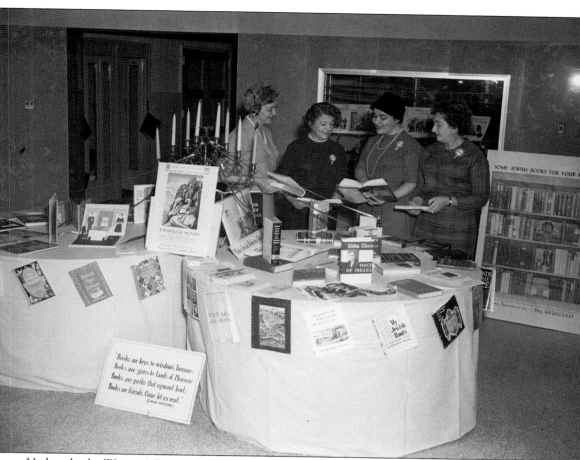

Hadassah, the Women's Zionist Organization of America founded in 1912, has members who "are motivated and inspired to strengthen their partnership with Israel, ensure Jewish continuity, and realize their potential as a dynamic force in American society." In this photograph from Jewish Book Month in November 1958, Hadassah tied Jewish identity to creating a Jewish home library.

A regular feature of Hadassah programming has been the use of theatrical skits to communicate the organization's message to the Jewish community. In this photograph from 1953, the creatively costumed Harrisburg actors promote fund-raising for Israel through the iconic tabletop "blue box" of the Jewish National Fund.

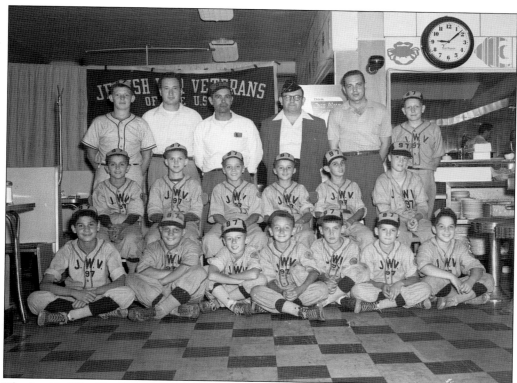

The Jewish War Veterans (JWV) Post No. 97 (later renamed Alexander D. Good JWV Post No. 97) was established in 1925. In this photograph from 1953, JWV members pose with a Little League team sponsored by the post.

During the 1950s, the JWV had a Ladies Auxiliary that engaged in public service. In this photograph from the 1950s, members pose with boxes for a book drive in front of the post home at 2138 North Third Street. The post and auxiliary also conducted hospital visits, sponsored a nursing scholarship, and extended support to the School for Veterans' Children in Scotland, Pennsylvania.

The Harrisburg section of the National Council of Jewish Women refers to "Jewish values of helping others" in its focus on promoting social services, civic involvement, and civil rights. During the 1960s, the Harrisburg section sponsored a school for community action, which addressed family and social issues. In this photograph from 1959, members of the Harrisburg section read to residents of the Children's Home of Harrisburg.

The Zionist Organization of America (ZOA), established in 1897, had a Harrisburg branch that was active in sponsoring programs for support of Israel. In this photograph, JCC president Roslyn Benjamin is joined in 1968 by ZOA chairman Harry Kessler (far left) and Macey Capin in talking to Rabbi Joseph Subow (far right) about plans for the 20th anniversary of Israeli independence.

Mary Sachs presents a certificate of honor to Rabbi Philip David Bookstaber at a testimonial dinner by the Harrisburg Council of the Jewish National Fund (JNF) on February 3, 1957. In making the award, Sachs iterated JNF's historic function of land reclamation and rehabilitation, establishment of agricultural settlements, and planting of forests.

These women from Beth El Temple promote the initial State of Israel Independence Bonds at a donor luncheon in 1951. The program to sell bonds to secure funding for immigrant absorption and the construction of vital infrastructure was successful and continued in the organization of annual campaigns.

Pictured here is a Young Judaea club from 1952. The oldest Zionist youth group in the United States, Young Judaea sponsored weekend conventions, social events, and educational programs in addition to a camping program with Hadassah.

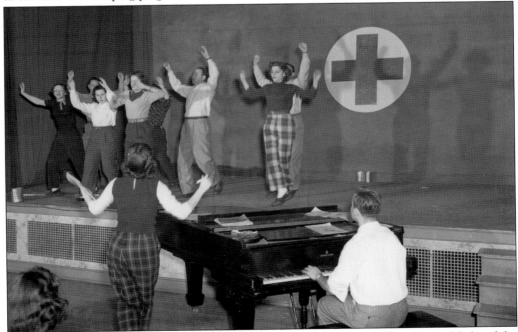

Hadassah's Harrisburg chapter organized an annual musical show, which was a highlight of the pre-Passover season. Arnold Zuckerman took this photograph of rehearsal before the 1951 show's opening on March 13 at the JCC. Sally Adlestein directed this and other original productions for the organization.

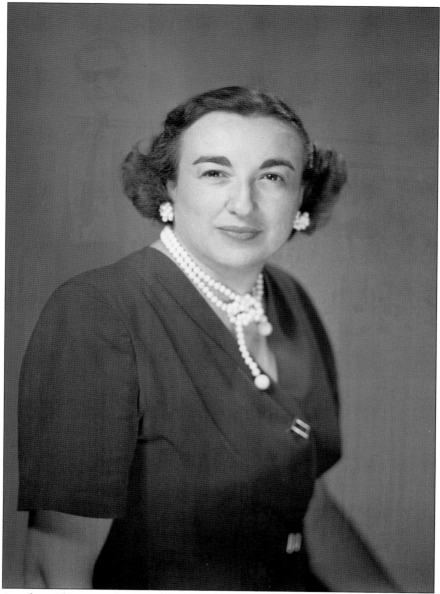

Sustaining the wide array of organizations and initiatives in the Jewish community depended on a force of committed volunteers. Many extraordinary individuals stand out through the history of the Jewish community. One such individual was Edna Silberman (1916–1993), who was frequently honored for her devotion to volunteer service work. Keystone Human Services named its top honor the Edna Silberman Humanitarian Award to recognize her contributions after she received the organization's first lifetime achievement award in 1990. She dealt with local social issues on a weekly television program called *Spotlight* for WGAL from 1963 to 1987. In the Jewish community, she served as president of the Harrisburg chapter of Hadassah and wrote a biweekly column for the *Community Review*. As chair of Harrisburg's Holocaust Remembrance Committee in the late 1980s, she is credited with initiating the area's first oral history project with local survivors and witnesses.

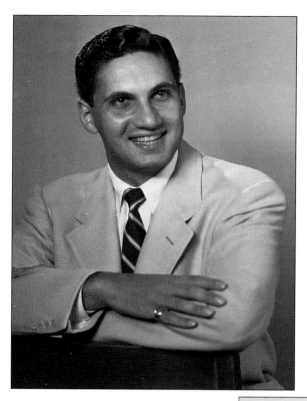

Arnold Zuckerman took these portraits of Morton and Alyce Spector in 1954. In the decades that followed, Morton Spector had leadership posts in a number of organizations, including the United Jewish Community (president, 1987–1989), Jewish Community Center (president, 1968–1970), Yeshiva Academy (president, 1985–1989), and the Jewish Home (president, 1995–1997).

Alyce Spector founded the Kidney Foundation of Central Pennsylvania, served as president of the Mental Health Association of the Capital Region, was a charter member of the National Council of Jewish Women, and served on the boards of the Institute for Cultural Partnerships and the Institute for the Advancement of Tolerance. The couple received a number of honors for their volunteerism and philanthropy. Israel Bonds gave them its Jerusalem-City of Peace Award in 1978, and Penn State Harrisburg, in 1988, named them corecipients of the Provost's Community Service Award. The Anti-Defamation League, in 1997, presented its Americanism Award to them for their work for diversity education and social causes.

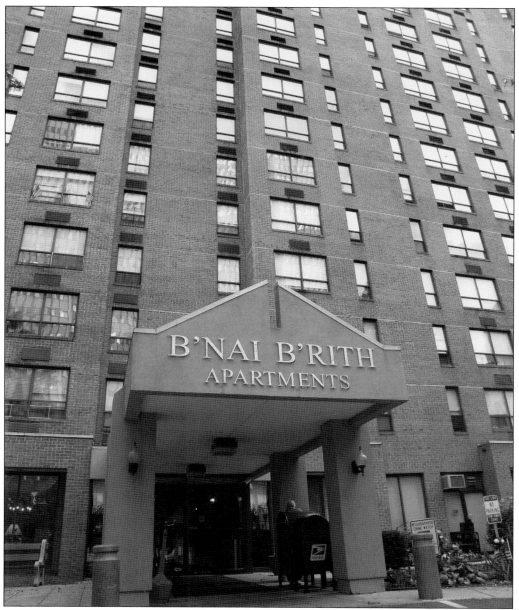

The 14-story B'nai B'rith Apartments at Third and Chestnut Streets in downtown Harrisburg was a project of the Salem Lodge of B'nai B'rith in Harrisburg. The nonprofit complex was erected, according to its founders, "in order to provide housing for senior citizens who wish to live independently with dignity and respect." The building, designed by architects of John Hans Graham and Associates, was dedicated on September 16, 1973. The apartments were renamed in 1993 for Harrisburg developer and Jewish philanthropist Abe Cramer (d. 1997), who was one of the project's original board members and who founded the national B'nai B'rith senior housing program in the late 1960s. Dr. I. O. Silver of Steelton was the first president of the apartments and led the board for 15 years; the building's auditorium was named the I. O. Silver Senior Center. (Photograph by Simon Bronner.)

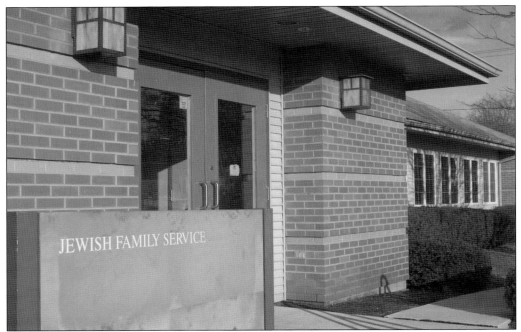

Established in 1964, Jewish Family Service of Greater Harrisburg (JFS) moved into this building on the Alex and Louise Grass United Jewish Community Campus in 1996. JFS's Jewish programming includes Kosher Meals on Wheels, resettlement aid to Jews from the former Soviet Union, outreach to Jewish young adults who are developmentally disabled, adoption services, and a Jewish healing center and library.

Established in 1989, the Jewish Group Home for adults with intellectual disabilities and autism on Second Street is located near the JCC. The facility is regarded as the first culturally focused community home in the nation intended to support Jews with disabilities. The home is run collaboratively by Keystone Human Service and JFS, which provides Jewish programming and prepares staff for holiday observances.

According to the *Community Review,* "Harrisburg discussed the question of the Jewish Home project for many years [a committee had been formed in 1949]—nothing was accomplished until Horace Goldberger resigned the presidency of the United Jewish Community [1969–1971] and graciously, with fired enthusiasm, took over the leadership of this project." Goldberger witnessed the culmination of his hard work when the first residents were admitted on April 13, 1977, and the building was dedicated two weeks later, but he died on June 6, amid speculation that he sacrificed his health for the project. (Courtesy Jewish Federation of Greater Harrisburg.)

Marilynn Kanenson, chair of the Jewish Group Home's advisory committee, speaks at the home's dedication in 1989. Involved in mental health advocacy for more than 40 years, including serving as president of the Tri-County Mental Health Association and the Dauphin County Case Management Unit, she also worked for the Jewish community as president of the federation in 1999. (Courtesy Jewish Federation of Greater Harrisburg.)

A second phase of development next to the Jewish Home occurred with the construction of "The Residence," a facility for residential independent and assisted living for senior adults. One of the special features is a surround-sound theater in which Jewish programming regularly occurs. (Photograph by Simon Bronner.)

Ann Sherman Feierman (left), head of Harrisburg's Yiddish Club, poses with Yiddish singer Susan Leviton before a monthly program held in the theater of The Residence. At the time this picture was taken, Feierman was 91 years old and still maintaining a vigorous organizational schedule. A member of boards for the JCC, Jewish Home, B'nai B'rith, Kesher Israel synagogue, and Dauphin County Area Agency on Aging, she also was president of the JCC Senior Club, a dance instructor at the JCC for 38 years, and exercise instructor at the Jewish Home and The Residence for 21 years. She has been described as the consummate volunteer and received numerous awards for her service, including the Guild of the Jewish Home Volunteer award, Jewish Federation of Greater Harrisburg's Mitzvah Heroes Award, and the Jewish War Veterans Auxiliary's Volunteer Woman of the Year. (Photograph by Simon Bronner.)

In March 1952, the boys of Ohev Sholom's Boy Scout Troop 10 had their investiture ceremony at the JCC. The ceremony welcomed a new Boy Scout into the troop as a "tenderfoot." In this photograph, Dick Simons (right) and Bert Goldberg (left) are the scoutmasters. Young Jewish boys in Harrisburg also had Troop 15 for scouting.

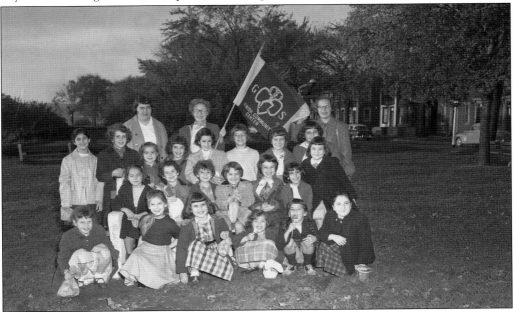

In November 1954, Arnold Zuckerman photographed the JCC's Brownie Troop 319 after the girls returned from a hike.

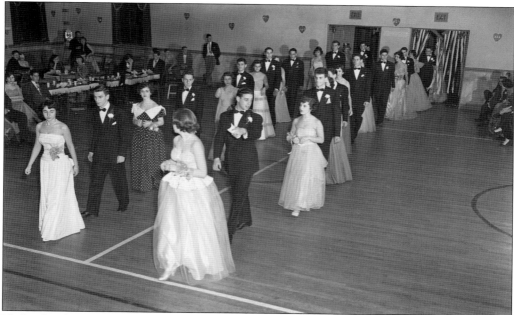

High school fraternities and sororities dominated the social scene of the 1940s and 1950s. The JCC had a separate fraternity sports league and played host to social events. Pictured here is the procession into the Sweetheart Dance sponsored by the Albert Hecht Chapter 128 of Aleph Zadik Aleph (AZA) on December 23, 1950. AZA was founded in 1924 as the male wing of the B'nai B'rith Youth Organization (BBYO). A highlight of the dance was the selection of the 1950 sweetheart. The picture below shows the presentation of the sweetheart on the JCC stage, where the winner was given a traditional sweetheart pin and gifts.

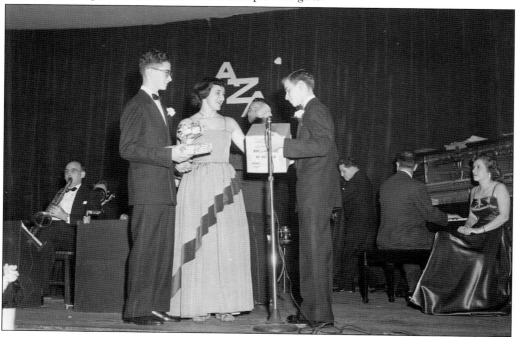

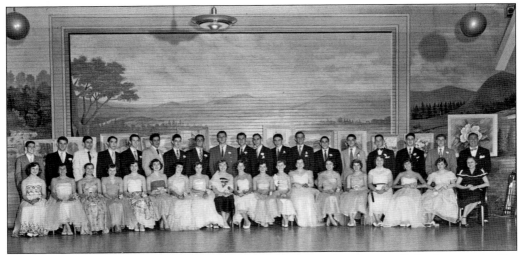

Sigma Alpha Rho's (SAR) big formal event was its Conclave Anniversary Ball, photographed by Arnold Zuckerman on November 10, 1951. The morning after the ball, SAR held a basketball tournament and a banquet. The fraternity was founded in Philadelphia in 1917 as a Jewish high school fraternity and spread westward to Harrisburg and Pittsburgh, among other cities in the region. Beginning in 1939, Central Pennsylvania had its own district council.

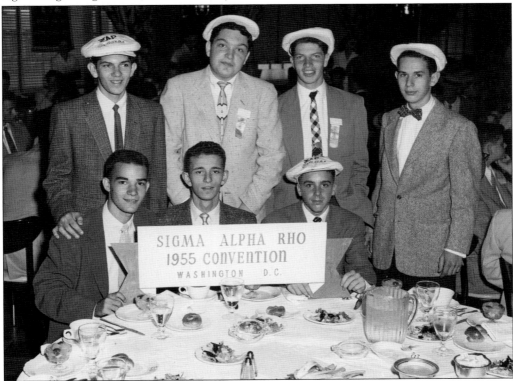

Representing Harrisburg's chapter at SAR's 1955 convention in Washington, D.C., were, from left to right, (first row) Bob Milrad, Ormond Urie, and Mike Karmatz; (second row) Herb Press, Sam Yespy, George Krevsky, and Harold Cohen. (Courtesy Herb Press.)

Members of Jewish fraternity Pi Tau Pi display a victory cup at a 1949 meeting with Rabbi Philip David Bookstaber (seated third from left) of Ohev Sholom. That year, the JCC's Fraternity Basketball League had four teams: Pi Tau Pi, Aleph Zadik Aleph, Sigma Alpha Rho, and Delta Rho Sigma.

Pledges for Phi Delta sorority show off a cake at the JCC in 1950. Irene Capin was the group's advisor.

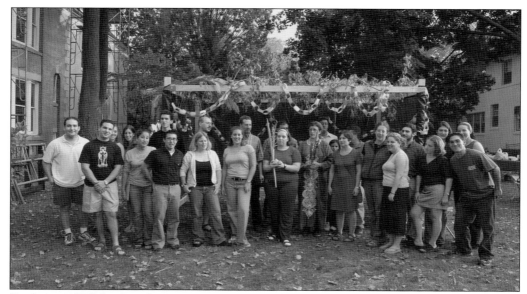

Students in Hillel, a Jewish campus organization, decorated a sukkah on the Dickinson College campus in Carlisle, Pennsylvania, in 2002, the year the adjacent Milton B. Asbell Center for Jewish Life was dedicated on High Street. The organization's advisor, Dr. Ted Merwin of Harrisburg, is the bearded man fifth from right. The center collaborates with the Carlisle congregation, Beth Tikvah, to cosponsor events, including High Holiday services and Passover seders. (Photograph by Pierce Bounds; courtesy Dickinson College.)

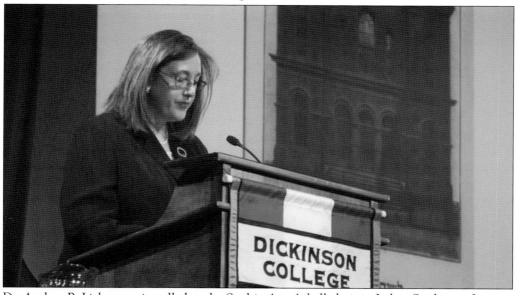

Dr. Andrea B. Lieber was installed as the Sophia Ava Asbell chair in Judaic Studies on January 30, 2004, at Dickinson College, the first academic chair of Judaic studies in the Greater Harrisburg area. In addition to her academic duties, Lieber has been active in Harrisburg's Jewish community, leading High Holiday services and the women's Passover seder, as well as serving on the boards of Beth El Temple, the yeshiva, and the Harrisburg chapter of Hadassah. (Photograph by Pierce Bounds; courtesy Dickinson College).

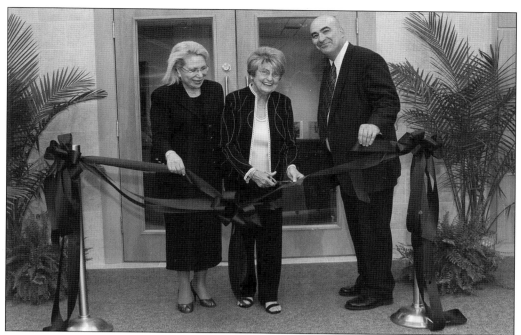

Holocaust survivor Linda Schwab (center) cuts the ribbon at the dedication of the Schwab Family Holocaust Reading Room, which contains an art gallery, seminar room, and reading area, in the Penn State Harrisburg library on June 7, 2007. The room's holdings include a digital oral history project of Holocaust survivors, witnesses, and liberators from the Greater Harrisburg area. Flanking Linda Schwab is campus chancellor Dr. Madlyn Hanes and Dr. Simon Bronner, lead scholar for the center and distinguished professor. In the photograph below, Linda (of Harrisburg) is pictured with her brothers Harold (right, of Carlisle) and Norman Swidler (left, of Shippensburg). Behind the trio, who had been hidden in Poland during the war, is a family picture taken after their 1949 resettlement to Harrisburg from a displaced persons camp. (Courtesy Penn State Harrisburg.)

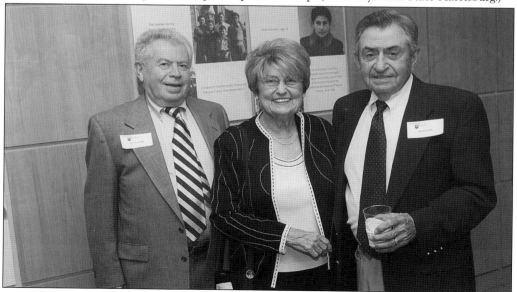

Arnold Zuckerman took this portrait of Morris "Morrie" Schwab (1917–2006) in 1959. Schwab received the United Jewish Communities of North America Endowment Achievement Award in recognition of his work to establish the Jewish Community Foundation of Central Pennsylvania. The foundation is devoted to fund-raising, investment, administration, and distribution of endowments, trusts, annuities, and other funds to benefit the Greater Harrisburg Jewish community. He served as president of the UJC from 1964 to 1966 and general chairman of the UJCA in 1961.

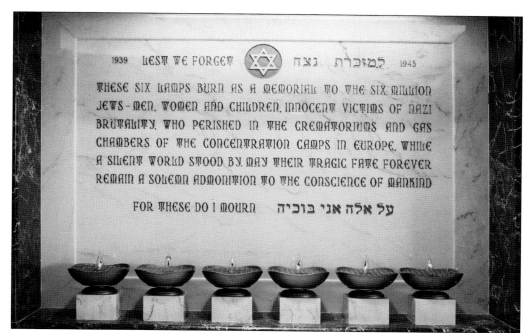

Organized Holocaust memorial programs increased in Harrisburg during the 1970s with the establishment of a Holocaust Remembrance Committee (later the Holocaust Education Task Force), organizations for survivors and the "second generation," and commemorations for Yom HaShoah (Holocaust Remembrance Day) and Kristallnacht (Night of Broken Glass). On June 9, 1977, the JCC dedicated a Holocaust memorial (pictured above) in its lobby with six eternal flames symbolizing the 6 million Jews who perished during the Holocaust. The sign on a yeshiva bulletin board links Yom HaShoah (right) to Yom Hazikaron (Israeli Fallen Soldiers and Victims of Terrorism Remembrance Day), followed by Yom Ha'atzmaut (Israeli Independence Day). (Both, photographs by Simon Bronner.)

This photograph shows the annual Reading of the Names, a 24-hour vigil during which the names of Holocaust victims are read continuously. The photograph taken during the mid-1990s at Chisuk Emuna shows the "Unto Every Person There is a Name" display, which comes from a poem by Ukrainian-born Israeli writer Zelda Shneurson Mishkowsky (1914–1984). (Courtesy Jewish Federation of Greater Harrisburg.)

From left to right, Holocaust survivors Leo Mantelmacher, Sam Sherron, and Kurt Moses join Harrisburg mayor Stephen Reed in breaking ground for the city's Holocaust memorial before the dedication in 1994. Originally planned to be near the JCC, the memorial was moved to Riverside Park at Front and Sayford Streets after the mayor offered the land in a more visible public location. (Courtesy Jewish Federation of Greater Harrisburg.)

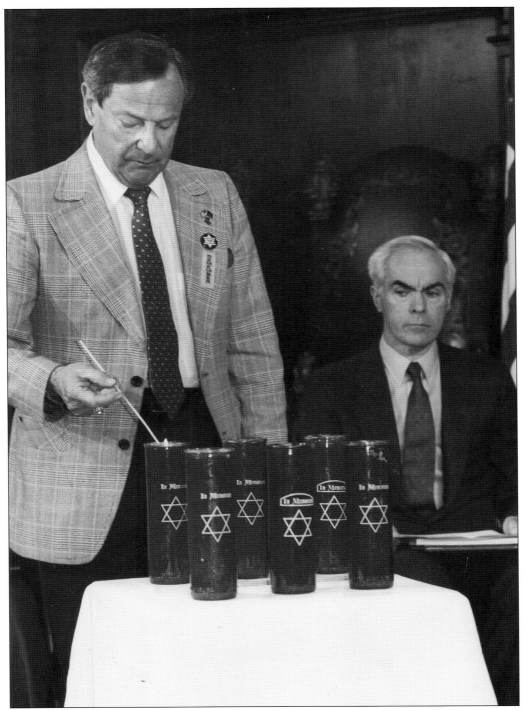

Lithuanian-born Holocaust survivor Sam Sherron lights memorial candles for the 6 million victims of the Holocaust at a state capitol commemoration, with Gov. Robert Casey Sr. (1932–2000) presiding in the background. (Courtesy Jewish Federation of Greater Harrisburg.)

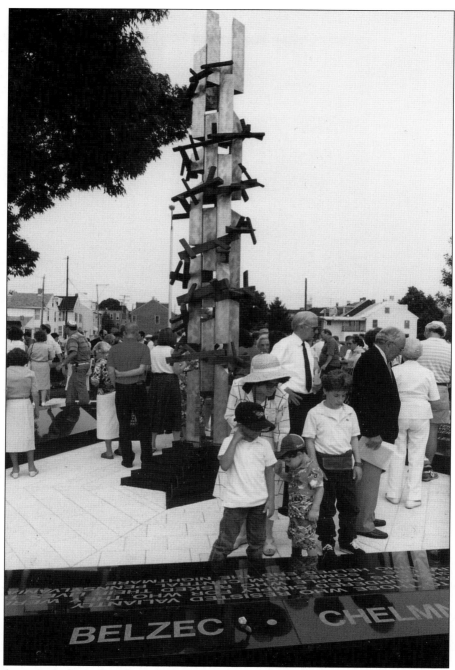

This photograph shows Jewish community members at the dedication of the Greater Harrisburg Holocaust Memorial Monument examining the texts surrounding the central sculpture on July 17, 1994. Nationally known artist David Ascalon designed the memorial. The memorial was refurbished and rededicated in 2007, and a three-paragraph marker was added with the closing phrase "Never Again." The site is used by the Jewish community for its annual Yom HaShoah observance. (Courtesy Jewish Federation of Greater Harrisburg.)

The Moses family dedicated this memorial on Yom HaShoah in 1998 to "victims of the Nazis' systematic and brutal persecution of Jews in Europe during the Holocaust, 1933–1945" in Beth El Temple's cemetery on South Progress Avenue in Harrisburg. (Photograph by Simon Bronner.)

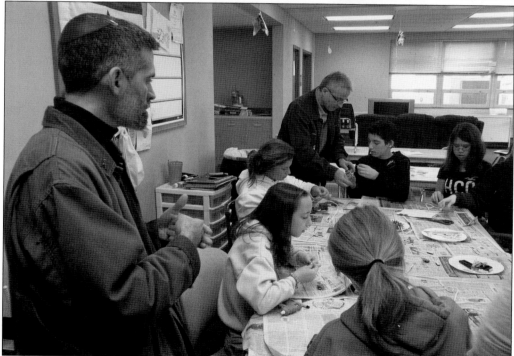

Rabbi Ron Muroff (in the left foreground) of Chisuk Emuna Congregation examines the work of youth at the JCC during the annual Mitzvah Day event working on "Dolls 4 Darfur" to help raise awareness about genocide in the Sudan. For years, Mitzvah Day brought together children and their parents to spend a day engaging in projects toward the goal of *tikkun olam*, repairing the world. (Photograph by Simon Bronner.)

In the Mary Sachs Auditorium at the JCC on Mitzvah Day, brothers Ross and Adam Wiener prepare sandwiches for a soup kitchen tending to the needs of the homeless and impoverished of the city. (Photograph by Simon Bronner.)

Five

BUSINESSES, PROFESSIONS, AND POLITICS

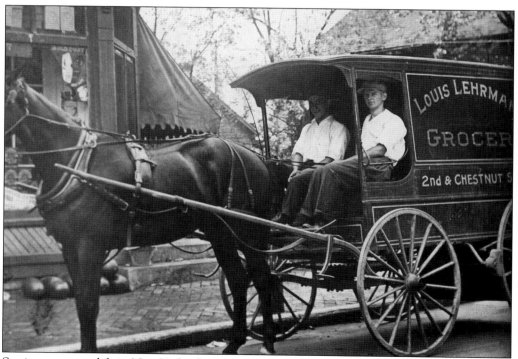

Setting up a new life in New York after emigrating from Russia in 1896, Louis Lehrman joined his older brother, Sam, in the expanding industrial town of Steelton around 1904. Sam had opened his Samuel Lehrman Grocery at Front and Chambers Streets, and Louis developed Lehrman's Grocery, shown in this photograph, at Second and Chestnut Streets. (Courtesy Lois Lehrman Grass.)

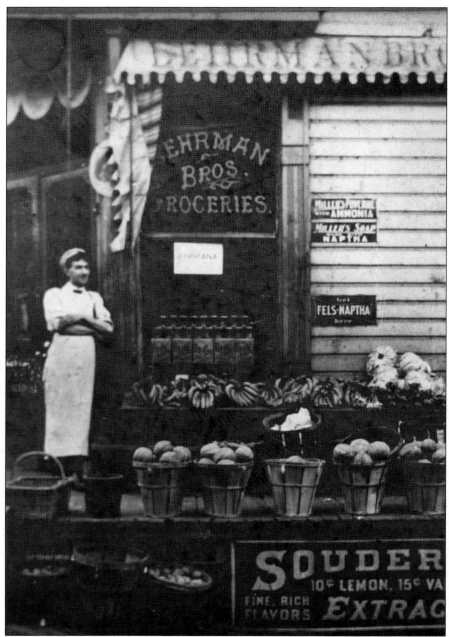

This photograph dating from the first decade of the 20th century shows the joint retail grocery trade established by Sam and Louis Lehrman in Steelton. Lehrman Brothers Groceries led to the formation of the Harrisburg Grocery Company (HGC) and, ultimately, separate business ventures from Louis and Sam in Harrisburg. Sam's business grew, and in 1935, he invested in the then-novel consumer enterprise of supermarkets in Washington, D.C., in partnership with N. M. Cohen of Lancaster. With Sam's seat on the supermarket chain's board taken by his son, Jac, the company developed Giant-Landover food stores and Super Giant department stores (not to be confused with sister company Giant-Carlisle described on page 101). (Courtesy Lois Lehrman Grass.)

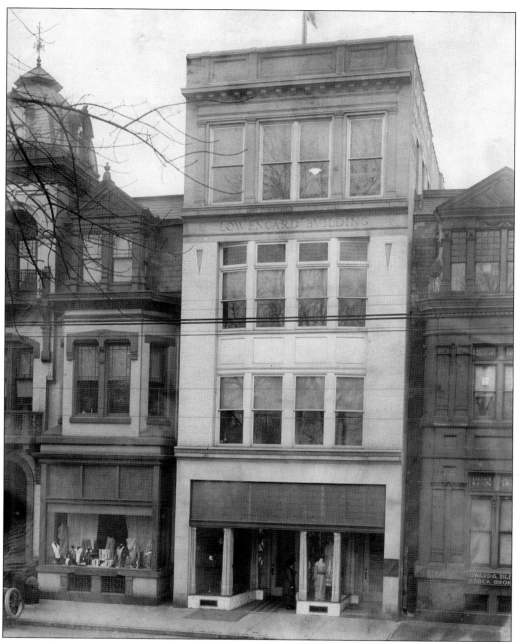

In 1916, brothers Harry and Leon Lowengard erected the Lowengard Building, designed by new Harrisburg architect Frank G. Fahnestock, for their printing and newspaper trade at 210 North Third Street. Their father, Joseph, had been one of the first Jews to settle in Harrisburg during the 1850s, entering into the clothing trade on Market Street. Visible on the first floor is Mary Sachs's women's clothing shop, opened on September 6, 1918. Mary Sachs was a Russian-born Jew whom the Lowengards helped with a loan and space in their building to launch her business. The shop was a success, and Sachs later bought the property next door at 208 North Third Street, adding lingerie, cosmetic, and jewelry departments.

Born to Lithuanian immigrants in Middletown, Samuel Singer (1894–1967) opened Sam Singer Men's Wear in Steelton in 1920. His sons, David and Edwin, carried on his entrepreneurial spirit by establishing Singer's Athletic Wear, with stores in Harrisburg's East and West Shore suburbs and York. Sam's third son, Morris, also participated in the family businesses. Sales of athletic supplies continue in the third generation. Many members of the Singer family remain in the Greater Harrisburg area and practice a number of professions: accounting, art curating, educational counseling, sports training, physical therapy, and information systems. (Courtesy Matthew Singer.)

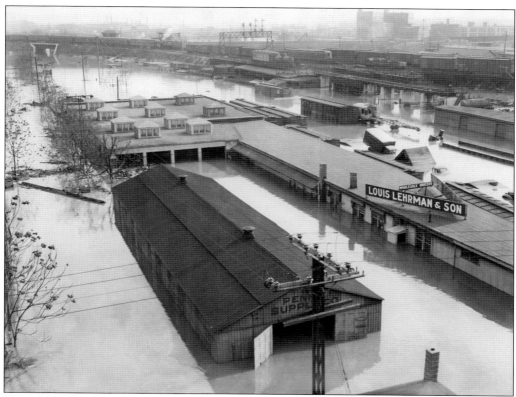

The wholesaling grocery enterprise of Louis Lehrman and Son, which later developed into the giant Rite Aid Corporation, was almost done in by the Great Depression and a disastrous flood of the Susquehanna River in 1936 (pictured above). Having seen the flood damage firsthand, Louis and his son, Ben, moved the business to higher ground at Seventeenth and Sycamore Streets.

In this 1960 photograph, Ben Lehrman (1907–1983), the "son" in Louis Lehrman and Son, is seated at his desk. He is credited with many of the innovations that brought about the company's rapid expansion in the 1930s, and he became the first chairman of the board of Rite Aid Corporation in 1962.

Originally from Scranton, Alex Grass (1927–2009) settled in Harrisburg after marrying Lois Lehrman in 1950 and became renowned for business and philanthropy. He launched Rack Rite Distributors in 1958, renting and stocking racks of non-grocery items for grocery stores as a subsidiary of Lehrman's company. In 1962, Rack Rite opened its first retail operation, the Thrif D Discount Center in Scranton and, with the addition of a pharmacy, renamed the stores Rite Aid. Grass became chairman and CEO of Rite Aid Corporation in 1968. By the time he retired in 1995, Rite Aid had become one of the leading drugstore chains in the United States and a Fortune 500 company. Besides serving in high-profile positions as national chairman of the UJA and chairman of the board of the Jewish Agency, in Harrisburg he was president of the UJC from 1971 to 1973, vice president of Ohev Sholom, and a board member of the Jewish Home. Past UJC president Harvey Freedenberg summarized, "Alex Grass was responsible for putting the Harrisburg Jewish community on the map of the national and international Jewish world." (Courtesy Jewish Federation of Greater Harrisburg.)

In 1918, Lithuanian-born Mary Sachs (1888–1960) opened a women's clothing shop on North Third Street that expanded into department stores. Known for championing Jewish and humanitarian causes, Sachs's work carries on through a trust in her name. A permanent exhibit of her life is on display by the entrance to the Mary Sachs Auditorium at the Harrisburg JCC. (Courtesy Jewish Federation of Greater Harrisburg.)

Mary Sachs's reputation for being independent-minded came through in 1920, when she hired the firm of Lawrie and Green to remodel the Weis mansion at 208 North Third Street to house her new shop. Sachs wanted the look to evoke upscale New York sophistication, and the result, a mix of Romanesque and classical influences, according to architectural historian Ken Frew, was a design "unlike anything in the city."

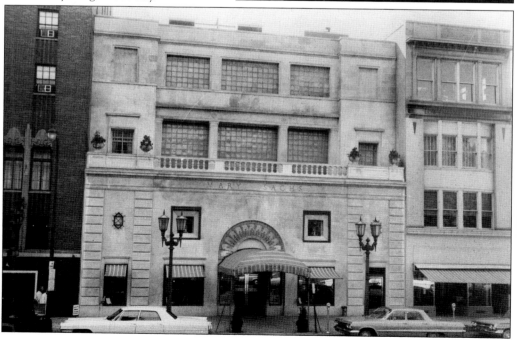

The sign for M. Lee Goldsmith furniture at a commercial exhibition boasts that the store has been in business since 1881. Lee (1889–1965) took over the store from his father, Joseph (1814–1929), and then passed the business to his sons, Richard S. and Joseph K. The business remained in the family until 1981.

Latvian-born Morris Brenner came to Harrisburg in 1910 and opened a neighborhood grocery, and his sons, Henry and Sam, started groceries of their own. The younger sons, Simon and Ephraim, bought a garage in Midtown that became M. Brenner and Son Motor Car Company. This photograph dates to 1954, when the Brenners moved the business to Paxton Street. Morris's grandsons, Michael and Edward, continued the family auto business for another generation.

Merv Woolf stands with his sister, Dottie, in front of their Lithuanian parents' wedding portrait (married 1912 in Harrisburg). The Woolfs entered the scrap metal trade, which was dominated by Eastern European Jewish immigrants who relied on social rather than financial capital. Later the family developed Woolf Steel, which providing structural steel for contractors. (Courtesy Penn State Harrisburg.)

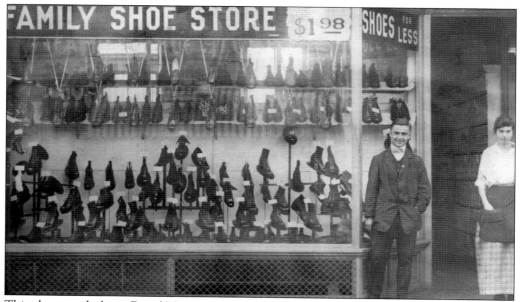

This photograph shows David Morrison in front of his Family Shoe Store at 4 South Front Street in Steelton. In 1910, of the 85 immigrant businesses listed in Steelton, 45 were operated by Jews from Eastern Europe. Loss of population with the decline of the steel plant and irrecoverable damage from Hurricane Agnes in 1972 forced many merchants to close or move. (Courtesy Center for Pennsylvania Culture Studies, Penn State Harrisburg.)

D&H Distributing Company made history, as the truck side announces, with the delivery of televisions to the region in the 1950s. D&H was established in 1918 by David Schwab and Harry Spector (the D and H standing for their first initials). The company became the largest distributor of RCA televisions and Whirlpool appliances in the United States. The Harry Spector Lounge at the JCC was named for the company's cofounder.

Morris Schwab stands third from the right in 1954 with staff of D&H showing off a color television line. On August 6, 1952, D&H's new "modern building" opened at 2535 North Seventh Street, where the business still operates. The family connection continued into the 21st century, when Harrisburg residents Dan and Michael Schwab, grandsons of David Schwab, began serving as copresidents of the company and oversaw a changing consumer electronics environment with computers, video games, and cell phones.

David Javitch (1899–1974), pictured at right, gained notice as the founder and CEO of Giant Food Stores and a leader of the UJC. The major supermarket chain began in 1923 when Javitch opened the small Carlisle Meat Market. In 1936, he purchased a full-line grocery in Lewistown, Pennsylvania, which he named the Giant Food Shopping Center. The stores spread in the 1950s with the expansion of suburban shopping centers. By 1968, the chain's ninth store opened in Harrisburg with Lee Javitch (below), David's son, serving as president of Giant Food Stores. Its store on Linglestown Road became known locally as the "Jewish Giant" because of its line of kosher foods and proximity to Jewish residences.

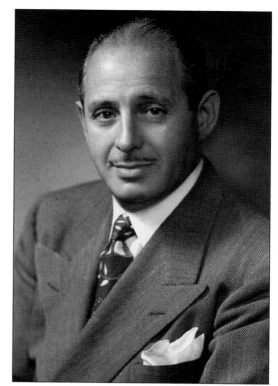

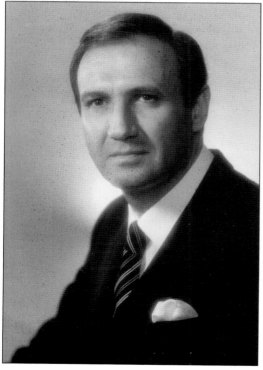

The Javitches sold the Carlisle-based company in 1981. Lee moved to New York, but the legacy of the Javitches remained with programs such as the David Javitch Memorial Lecture at Beth El Temple and Lee's tenure as president of the temple and board member of the yeshiva. (Courtesy Jewish Federation of Greater Harrisburg.)

Harrisburg-area Jews were integrally involved in union activity, especially the International Ladies Garment Workers Union (ILGWU) Local 312, for which Jewish figures such as Abraham Epstein, Marvin Rogoff, and Sol Hoffman played pivotal leadership roles during the mid-20th century. The membership of the ILGWU had a sizeable Jewish presence. Here in 1962, ILGWU representatives hand out leaflets urging a boycott of millinery products to shoppers of Pomeroy's Department Store in downtown Harrisburg.

Arnold Zuckerman was a prominent Jewish commercial photographer in Harrisburg, where he operated Arnold Studios on North Third and North Sixth Streets from 1946 to 1977. Born in Harrisburg in 1924, he was trained as a navy photographer in World War II. He launched his business upon his return to Harrisburg, relying on the major clients of the JCC, Jewish social organizations, Harrisburg Community Theater, and Harrisburg-area synagogues, businesses, and unions. This photograph is from his booth at a Harrisburg trade exposition in 1960.

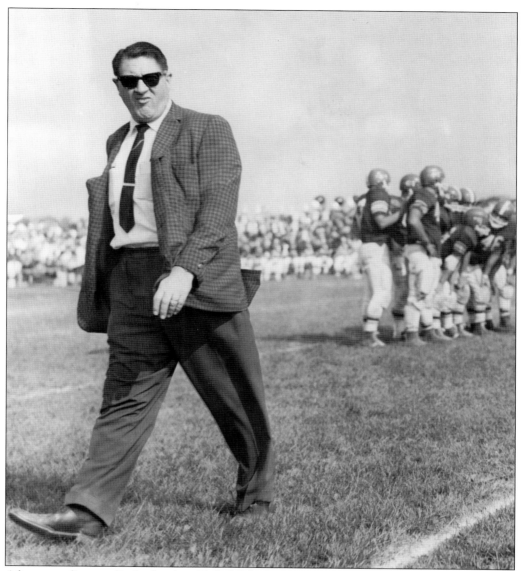

After attending medical school in Philadelphia, Dr. I. O. Silver (1909–1994) returned to his hometown of Steelton to treat local residents and athletic teams until 1986. He was inducted into the Pennsylvania Sports Hall of Fame and the Harrisburg Jewish Sports Hall of Fame for his contributions to area teams. For the Jewish community, he was a founder of B'nai B'rith Apartments and the Harrisburg Chapter of the American Society for Technion. He also had an impact on the medical profession; the I. O. Silver Foundation, sponsor of the I. O. Silver Games, was established in 1996 in his honor to support care of patients with cardiovascular disease. (Courtesy Susan Silver Cohen.)

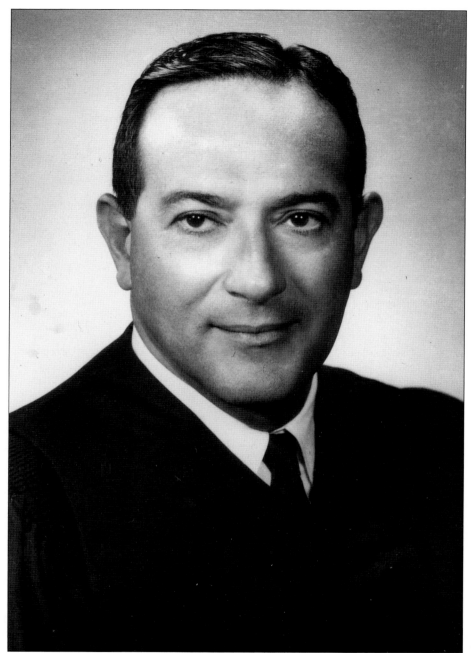

In 1965, Gov. William Scranton appointed decorated World War II veteran William Lipsitt (1917–2009) of Harrisburg to be judge of the Court of Common Pleas of Dauphin County. He gained notoriety in his 20-year term for presiding over some of the most famous trials in the region, including the "666" lottery fix trial, Jay Smith murder trial, and Three Mile Island (TMI) litigation. His numerous civic and Jewish organizational activities included serving as president of the Harrisburg School Board, a member of the executive committee of the UJC, national delegate to the American Jewish Committee, and president of the Keystone Area Council of Boy Scouts of America.

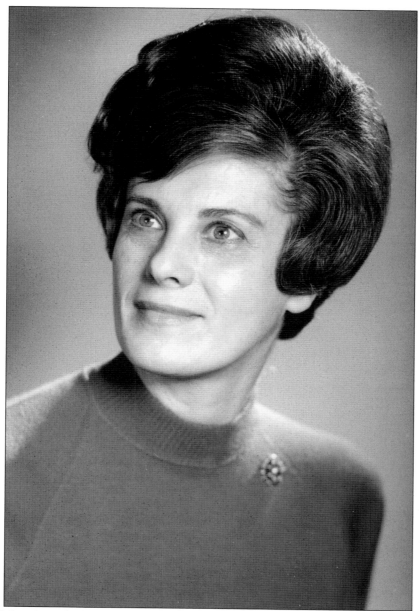

Miriam "Mim" Menaker (1921–2000) was the first woman and first Jew elected to the Harrisburg City Council. She served from 1969 to 1981, the last two years as president. From 1972 to 1982, she was treasurer of the Pennsylvania League of Cities. For her long service, the area in front of Harrisburg's City Government Center was named the Mim Menaker Plaza. She had numerous roles in the Jewish community, including being the first woman to chair the UJCA. A talented singer and supporter of the arts, she was the director of Beth El Temple choir for many years and president of the synagogue's sisterhood. She received many awards in her lifetime, including the Anti-Defamation League's Americanism Award, Jewish Theological Seminary's National Community Leadership Award, and the UJC's Albert Hursh Leadership Award. (Courtesy Jewish Federation of Greater Harrisburg.)

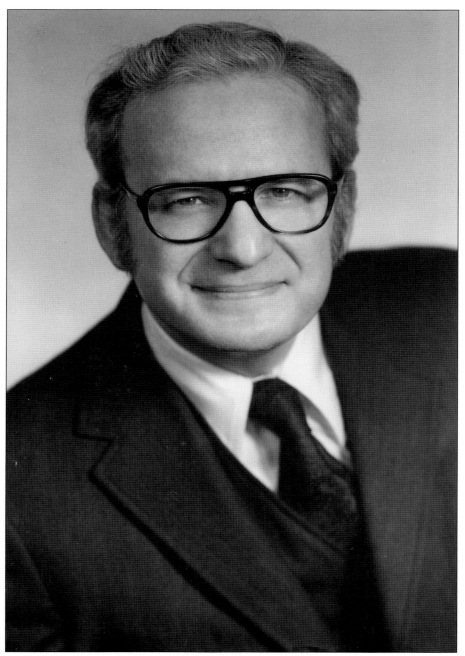

Born in Harrisburg in 1926, F. M. Richard Simons established the insurance firm of Simons and Company in 1949 and went into city politics beginning in the 1970s as Democratic committeeman of the 14th Ward. He was city treasurer from 1976 to 1980 and was also elected to Harrisburg City Council in 1990. Among his other civic and religious work, he served as president of the Beth El Temple's brotherhood, vice-president of the UJC, treasurer of the Dauphin County Hospital Authority, and board member for Harrisburg State Hospital and Planned Parenthood of Pennsylvania.

The UJC was active in the "Free Soviet Jewry" movement during the 1970s and helped resettle Russian Jews in the Harrisburg area. In this photograph from 1978, Russian interpreter Diane Sand of Harrisburg (right) talks with Wanda Osnis, who had come to Harrisburg to speak at the JCC on dissidents in the Soviet Union.

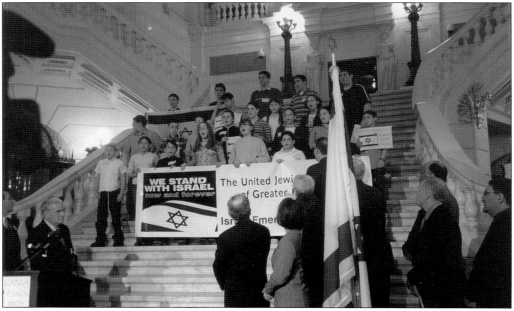

Children from the Harrisburg Jewish community sing at a rally for Israel coordinated by the Pennsylvania Jewish Coalition on May 8, 2002, in the state capitol rotunda. UJC executive director David Weisberg, Israeli consul general Giora Becher, state senator Jeff Piccola, and Lt. Gov. Robert Jubelirer protested suicide attacks on civilian targets in Israel. (Courtesy Jewish Federation of Greater Harrisburg.)

The 60th anniversary of the founding of the state of Israel in 2008 was the occasion for celebratory events globally. In Harrisburg in May 2008, shofar blowers opened a "Walk the Land" march in support for Israel along the Susquehanna River. (Photograph by Simon Bronner.)

Six

ARTS, CULTURE, AND RECREATION

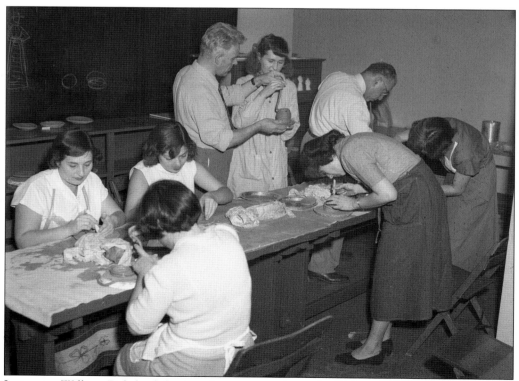

Instructor William Rohrbech leads a class on ceramics at the JCC in 1950. An adult education committee chaired by Robert Finkelstein offered a full slate of courses on art, sewing, film, public speaking, social dancing, Jewish history, and Hebrew.

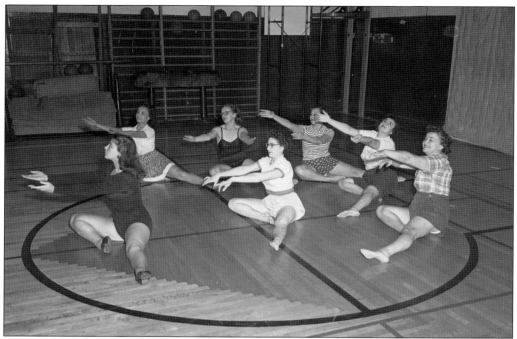

Dance instructor Joan Zelinka leads a modern dance class at the JCC in 1952. The JCC also had programs for ballet for children and adults in this period.

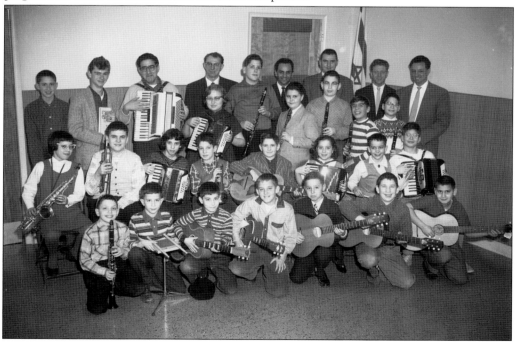

Charles Stabile (fourth row, far right) was director of the JCC School of Music when this photograph of the school's students and faculty was taken in 1960. Stabile also owned the Stabile Studio of Music and played for the Harrisburg Symphony Orchestra.

In this January 25, 1960, photograph, 50 teenagers from the Harrisburg JCC's production of *Leave it to Jane* attend a Broadway showing of the play. To program director Maurice Finkelstein, the JCC dramatic production featuring "an all-teen cast" was "preventive therapy for juvenile delinquency." In the 1920s, the old Y featured the Center Players, and the program continued into the 1930s with the Jewish Community Players, leading local historian Michael Coleman to comment, "In no cultural enterprise did Jews [of Harrisburg] participate more enthusiastically than in the legitimate theater."

L'il Abner, directed by Al Effrat, was performed in December 1966 at the JCC. The production was considered ambitious because it employed over 70 cast members and even more than that working behind the scenes. The JCC reprised the musical comedy in December 1977.

When businessman Philip Menaker (owner of Capital Bedding Company) died in December 1967, the *Community Review* credited him with being "one of the early pioneers to promote a Jewish arts program in the JCC." As president of the JCC from 1938 to 1940, he initiated an educational program that went beyond Jewish studies to include a music guild, dance, arts and crafts, and dramatics. (Courtesy Jewish Federation of Greater Harrisburg.)

The husband-and-wife team of Nancy and Jay Krevsky (formerly principal of Harrisburg's Arts Magnet School) performed in more than 100 plays from the late 1950s, including many Jewish-themed productions such as *Fiddler on the Roof*, shown here at the Harrisburg Community Theater in 1971. The renovated production center for Theatre Harrisburg at Sixth and Hurlock Streets was named in their honor in 2004. (Courtesy Jay Krevsky.)

Commenting on the adult education program for 1953, the *Community Review* stated, "The art courses are among the most popular of the classes offered at the center." That legacy continued after 1958 in the uptown center building, where Arnold Zuckerman snapped this photograph of the dedicated art space.

Since 1982, the Harry Spector Lounge at the JCC has been a gallery for Jewish-themed arts by local and national artists. Pictured here is the traveling photograph exhibition by Janice Rubin titled "Survival of the Spirit: Jewish Lives in the Soviet Union." (Courtesy Jewish Federation of Greater Harrisburg.)

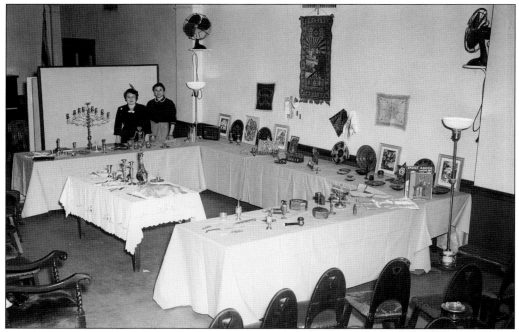

At this program for the Harrisburg Hebrew School PTA meeting in November 1953, women were advised to decorate their homes with ceremonial Jewish objects and embellish them, fulfilling *hiddur mitzvah* (the beautification of performing a commandment).

Susan Leviton created this paper-cut design for the Susquehanna Tzedakah Society, recognizing individuals who have created major endowments with the Jewish Community Foundation for a Jewish community purpose. She was a Pennsylvania Humanities Council Commonwealth Speaker, touring the state to demonstrate the art of Jewish paper cutting. (Photograph by Simon Bronner.)

114

Arnold Zuckerman took this photograph of Albert "Al" Morrison at the piano in 1959 with a small ensemble. Morrison also led a big band during the 1950s and 1960s that entertained during the JCC's annual youth festival and other events. Morrison was still playing in 2010, bringing a Jewish songs program to the Jewish Home and Residence as well as the JCC.

A folk dance troupe leads community members through Israeli and Eastern European Jewish folk dance at the Lower East Festival held at the JCC in 1982. Folk dance continued to be taught and performed in Harrisburg-area Hebrew schools and JCC programs into the 21st century. (Courtesy Jewish Federation of Greater Harrisburg.)

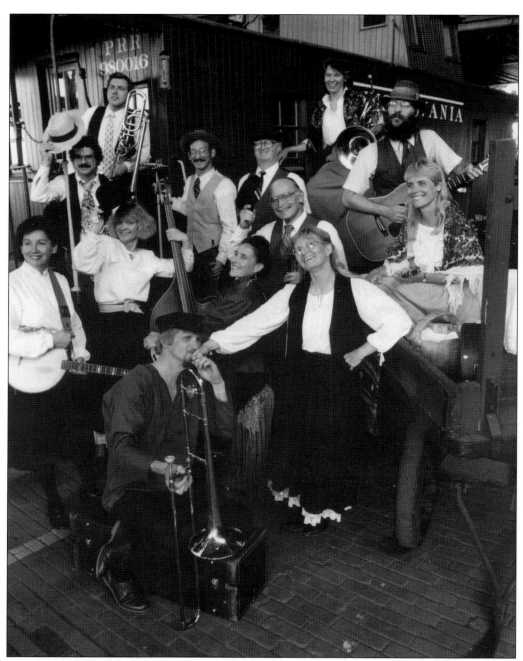

The Old World Folk Band, shown here with its lineup in 1990, was a resident klezmer group at the JCC beginning in 1982. The band joined younger revival musicians with traditional Harrisburg Jewish performers Stan Green (tipping his hat in center) on violin and Al Goodman on piano (standing to the left of bearded guitarist Henry Koretzky). Originally an instrumental group rehearsing at the JCC, the band added Susan Leviton as vocalist performing songs in Yiddish (seated above trombonist Dale Laninga, a founding member). The group issued five commercial recordings. (Courtesy Jewish Federation of Greater Harrisburg.)

Tony Award–winner Stuart Malina came to Harrisburg in 2000 as music director and conductor of the Harrisburg Symphony Orchestra. Known for his versatility, Maestro Malina has performed Jewish-themed music and composed a number of works to Hebrew biblical texts. He served on the Beth El Temple board and is a synagogue favorite at Purim, reading the Megillah in costume. (Courtesy Stuart Malina.)

Ayelet Shanken (left), chair of the Harrisburg Jewish Film Festival Committee, poses with New York filmmaker Lisa Gossels before the screening of her award-winning film *Children of Chabannes* in 2009. Francine Feinerman and Lorri Bernstein organized the first film festival in 1994, and it has become a much-anticipated annual series of screenings, often with special appearances by filmmakers and critics. (Courtesy Penn State Harrisburg.)

march 1995 . volume 1 . number

Harrisburg

M · A · G · A · Z · I · N · E

LOIS GRASS

the region's 'queen of culture'

In March 1995, *Harrisburg Magazine* bestowed the title of the region's "queen of culture" in its cover story on Lois Lehrman Grass. Four years later, she received the Governor's Patron Award for the Arts. Often mentioned in accolades is her patronage of the Whitaker Center for the Science and Arts, the Rose Lehrman Arts Center at Harrisburg Area Community College, Harrisburg Artsfest, WITF public broadcasting, and the Lois Lehrman Grass Foundation. She is known also in the Jewish community for her support of Jewish Family Service, the National Council of Jewish Women, and March of the Living. Among her many awards are the Holocaust Task Force Distinguished Service Award, Mildred Hand Award from Ohev Sholom, and her designation by the governor as a Distinguished Daughter of the Commonwealth of Pennsylvania. (Courtesy Benchmark Media.)

Florence Bennett examines Yolanda Rosenschein's weaving of a *tallit* (prayer shawl) for a grandchild's bar mitzvah at Beth El Temple in 1984. The synagogue encourages members to creatively weave religious articles by providing a loom and guidance. (Photograph by Simon Bronner.)

Judy Goldberg shows an embroidered *wimpel* (Torah binder). Goldberg also creates Jewish-themed quilts and other textile arts. (Photograph by Simon Bronner.)

This illuminated *ketubah* completed by Harrisburg artist Susan Leviton was used in the wedding of a Harrisburg Jewish couple in 1998. Owner of Harrisburg-based art studio Levworks since 1980, Leviton is nationally known for her traditional and original artwork using homemade paper, Hebrew calligraphy, ink, paint, textiles, and paper cutting for a variety of Jewish forms. (Photograph by Simon Bronner.)

Children at Beth El Temple and other synagogues annually craft objects related to Hanukkah and other holidays. The girl on the left is painting a dreidel, while the boy on the right decorates a plate for latkes (potato pancakes). (Photograph by Simon Bronner.)

David Herman, 2009–2010 president of the Jewish Federation of Greater Harrisburg, gives hand-baked *hamantaschen* (three-cornered pastries with filling specially made for Purim) to an attendee at the JCC's annual Purim carnival. Bakers provide a colorful array of filling choices for the pastries, including poppy seed, prune, apricot, and raspberry. (Photograph by Simon Bronner.)

A boy spells out his name in baked Hebrew letters before his *chalakah* (Sephardic version of the Ashkenazic *upsherin*, a traditional haircutting ritual at three years old). The consumption of sweet letters signals the beginning of Hebrew learning for the child. (Courtesy Lauren Castriota.)

Many Jewish households in Harrisburg have cabinets in which they display Judaica and family mementos. Carl Shuman went one artistic step further to connect to his family and ethnic heritage by redecorating his grandmother's cabinet with Hebrew calligraphy, floral designs, and cartouches. Shuman also works in metal, making artful *mezuzot* and other Jewish-themed sculptures.

Following in the footsteps of photographer Arnold Zuckerman as an artful portraitist and chronicler of Greater Harrisburg's Jewish events for a digital age is Josh Barry (b. 1979), who grew up in the community. (Courtesy Josh Barry.)

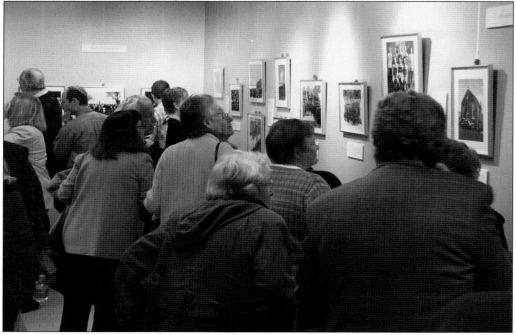

A crowd in 2008 examines photographs of Greater Harrisburg's Jewish history. The images were installed in the gallery of the Schwab Family Holocaust Reading Room at Penn State Harrisburg, which is devoted to exhibitions of visual arts related to Holocaust and Jewish studies. (Courtesy Penn State Harrisburg.)

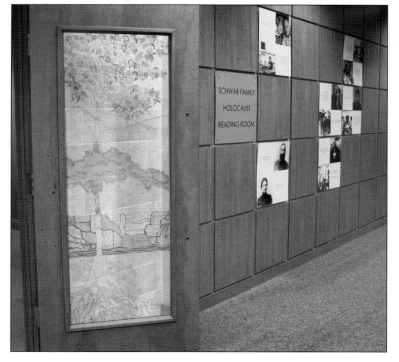

The Schwab Family Holocaust Reading Room at Penn State Harrisburg was designed in 2006 by Harrisburg-area architects Henry and Deborah Cohen, who also had commissions at Ohev Sholom and B'nai B'rith Apartments. The door designs were completed by Harrisburg artist Susan Leviton and installed in etched glass. The tree motif represents the persistence and regrowth of Jews despite various obstacles in history. (Courtesy Penn State Harrisburg.)

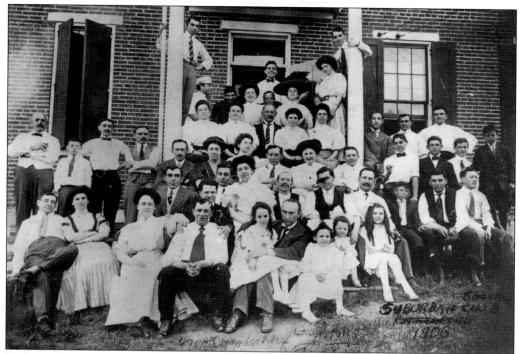

In the early 1900s, German Jews who had arrived in the 19th century in advance of the Russian immigrant wave organized the short-lived Suburban Club in Lawnton (5 miles east of downtown Harrisburg) as an ethnic, family-oriented social and recreational center. At the time this photograph was taken in 1906, families at the club played baseball, tennis, and cards. (Courtesy Richard Goldsmith.)

Dr. Benjamin Gainsburg, outraged in 1936 by the possible sale of a formerly public golf course in Lower Paxton Township to a private concern that planned to exclude Jews, arranged with fellow Jewish businessmen Jacob Miller and Edward Schleisner to purchase the property. The group created Blue Ridge Country Club, a private, nonrestricted club offering a regulation 18-hole golf course, swimming, tennis, and dining to members.

In 1929, the Hershey Park swimming pool opened to the public. Pictured in 1931, Ruth Tuch Kusic (left) and Pauline Hoffman made the trek from Harrisburg to take a dip during the summer of 1931. In the late 20th century, the park accommodated its Jewish patrons observing kashrut by providing a kosher food stand. (Courtesy Matthew Singer.)

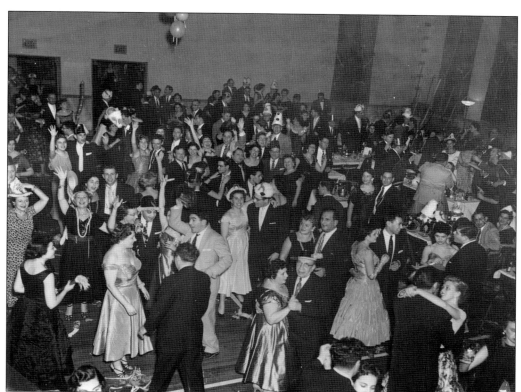

The JCC ballroom was the location of a number of annual banquet-dances during the 1940s and 1950s for the celebration of American holidays such as New Year's, George Washington's birthday, and Thanksgiving. Arnold Zuckerman took this photograph above the dance floor for the New Year's Ball of 1952.

Onlookers pass by a drink stand at a Jewish cultural festival in 1982. For many suburbanized, assimilated Jews, the displays conveyed nostalgia for the community's roots in old Jewish neighborhoods and immigrant trades that were shared by many Harrisburg Jewish families. (Photograph by Simon Bronner.)

127

www.arcadiapublishing.com

Discover books about the town where you grew up, the cities where your friends and families live, the town where your parents met, or even that retirement spot you've been dreaming about. Our Web site provides history lovers with exclusive deals, advanced notification about new titles, e-mail alerts of author events, and much more.

Find Your Place in History.